RACINET'S
Full-Color Pictorial
History of Western Costume

With 92 Plates Showing Over 950 Authentic Costumes
from the Middle Ages to 1800

AUGUSTE RACINET

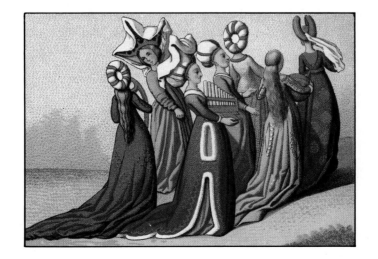

DOVER PUBLICATIONS, INC. • NEW YORK

Published in Canada by General Publishing Company, Ltd.,
30 Lesmill Road, Don Mills, Toronto, Ontario.
Published in the United Kingdom by Constable and Company, Ltd.,
10 Orange Street, London WC2H 7EG.

This Dover edition, first published in 1987, is a new selection of plates
from the six-volume work *Le Costume historique*, originally published by
the Librairie de Firmin-Didot et Cⁱᵉ, Paris, in 1888. The new English
captions are based on information in the French original. See Publisher's
Note for further bibliographic details.

Manufactured in the United States of America
Dover Publications, Inc., 31 East 2nd Street, Mineola, N.Y. 11501

Library of Congress Cataloging-in-Publication Data

Racinet, A. (Auguste), 1825–1893.
Racinet's full-color pictorial history of western costume.

"Selection of plates from the six-volume work,
Le costume historique, originally published by
the Librairie de Firmin-Didot et Cie, Paris,
in 1888"—verso t.p.
1. Costume—Europe—History. I. Title. II. Title:
Full-color pictorial history of western costume.
GT575.R332513 1987 391'.0094 87-13610
ISBN 0-486-25464-X (pbk.)

PUBLISHER'S NOTE

Albert-Charles-Auguste Racinet (1825–1893) was well known to his French contemporaries as a talented painter who exhibited at the Salon from 1849 to 1874 and contributed illustrations to such prestigious historical works as Paul Lacroix's *Le Moyen-Âge et la Renaissance* (1851). But Racinet's true monuments are his two publications *L'Ornement polychrome*, which appeared between 1873 and 1887 and finally included 220 color plates depicting historical ornament from a vast range of eras and cultures, and *Le Costume historique*, from which the plates in the present volume are reproduced.

The 500 plates of *Le Costume historique*, of which 300 are in full color and the rest in monochrome, were issued to subscribers in twenty installments between 1876 and 1886. By 1888 the work was published in small-quarto book form as five plate volumes (Vols. 2–6, each containing 100 plates and accompanying text) and one volume (Vol. 1) of prefatory and tabular matter. There was also a folio edition. Though the book is chiefly concerned with costume, as the title would indicate, many of the plates also illustrate interiors of dwellings, household furniture and accessories, weapons, tools, vehicles and other related items. The main divisions of the work are: the ancient world (plates 1–59), the non-European world (plates 60–180), the Christian world from Byzantium through the early nineteenth century (basically, Western Europe with a heavy emphasis on France; plates 181–410, obviously the heart of the work) and contemporary (nineteenth-century) European folk costume (plates 411–500).

The present selection of 92 plates, reproduced 20% larger than the originals to add both clarity and impressiveness, includes 83 plates from the western European historical division and 9 plates (those on Scotland, Russia and Poland) which were placed by Racinet within the final folk-costume division but are actually historical and help to complete the picture of the mainstream of European fashion from the early Middle Ages to Napoleonic times. The selection begins about 900 A.D. (Byzantine costume is omitted) and includes only full-color plates and only plates that are altogether or almost altogether devoted to clothing; once monochrome and nonclothing plates were set aside, it was necessary (to arrive at a book of the desired length) to omit only a relatively small number of the four-color plates covering Europe between ca. 900 A.D. and ca. 1800 A.D. (most of those omitted

are either quite pale in color, weak in drawing or repetitious). The captions, newly adapted from the original French text, are not intended to be more than identifying labels fixing the images in place and time; analysis of the fashions was out of the question for the present publication.

Racinet's full-color plates, printed by chromolithography, were prepared on the basis of old documents and works of art by a number of capable commercial artists, identified in the original edition at the lower left-hand corner of each plate. The following artists are represented in the Dover selection (the numbers being those of the plates in the *present* volume):

Allard: 16, 17.
Brandin: 75.
Charpentier: 39, 48, 58, 59.
Chataignon: 29, 30, 33.
Durin: 1, 4, 28, 52, 82, 83.
Fieg: 2, 13.
Gaulard: 38, 71, 73, 78, 81, 86, 87.
Girard: 25–27.
Guyard: 45.
Jauvin: 5, 32, 34, 60.
Lestel: 3, 12, 37, 61, 69.
Leveil: 76, 77.
L. Llanta: 21, 23, 50, 64, 65, 72.
Schmidt: 6, 7, 18, 20, 35, 36, 53.
Thadé: 70, 84, 85, 88–92.
Urrabieta: 11, 19, 22, 49, 51, 54–57, 66, 74, 79, 80.
Vallet: 8, 9, 10, 14, 40–44, 46, 47, 62, 63, 67, 68.
Werner: 15, 24, 31.

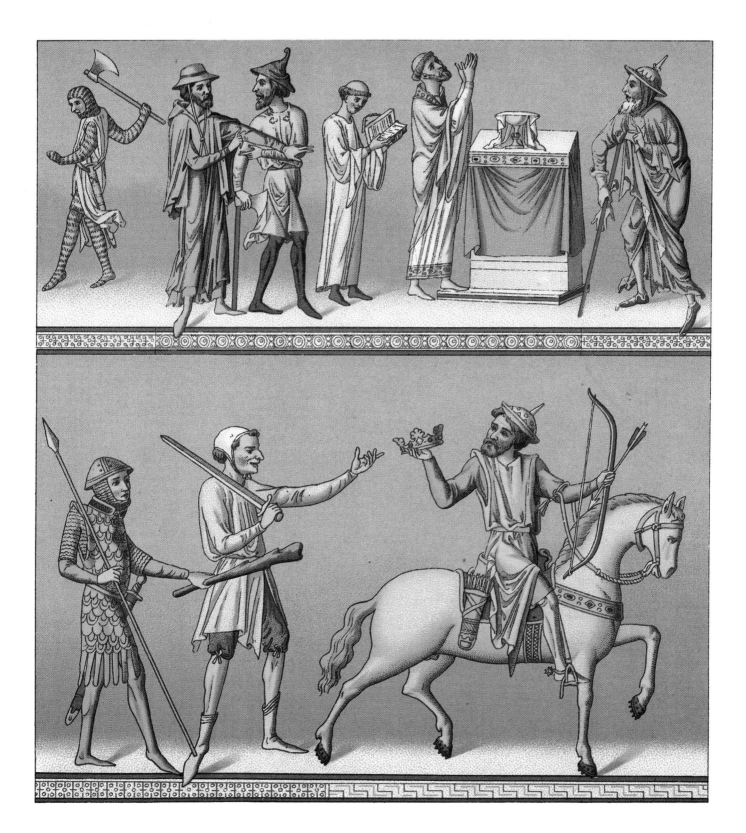

PLATE 1 · French Civil, Military and Religious Garb, 9th Century (?).

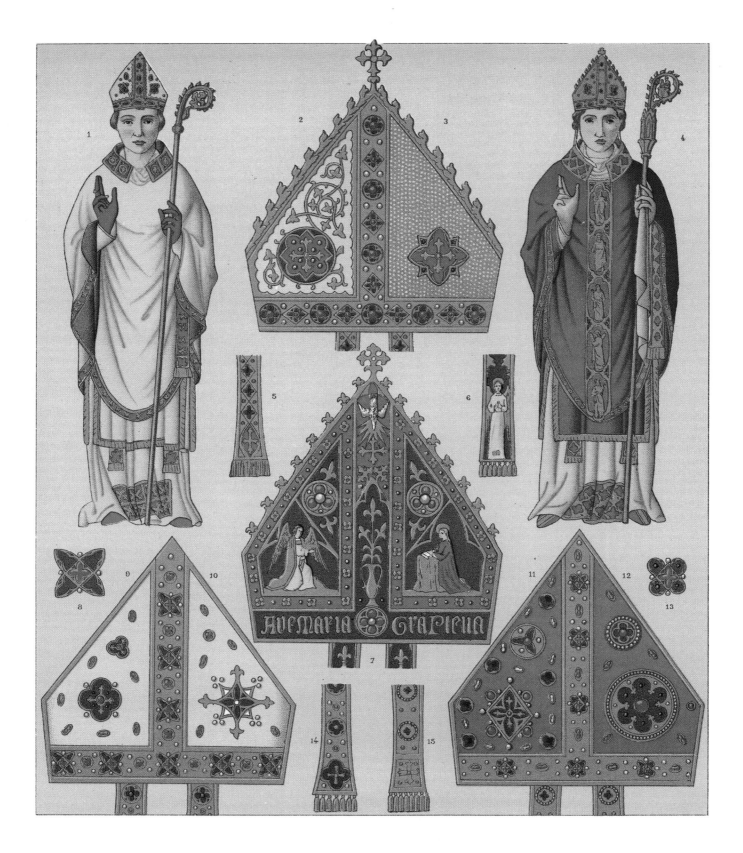

PLATE 2 · Bishops, 14th Century.

1, 4: Bishops in full vestments. 2, 3, 7, 9–12: Miters. 5, 6, 14, 15: Details of the fillets of the miters. 8, 13: Embroidery motifs from the miters.

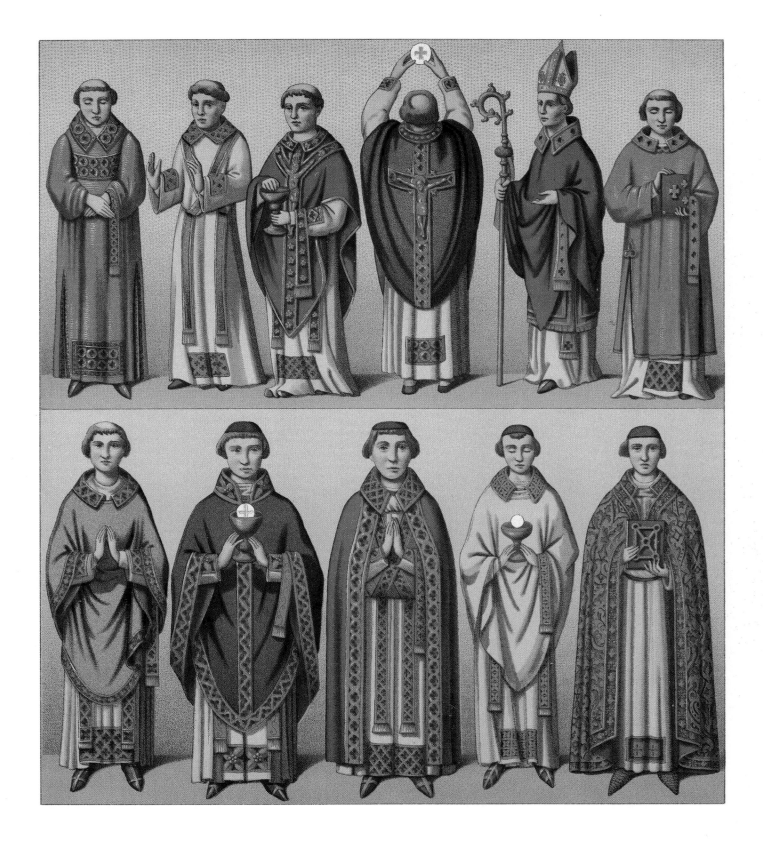

PLATE 3 · Medieval Sacerdotal Vestments.

TOP, LEFT TO RIGHT: Roman deacon, 1450; priest with alb; priest with chasuble; Venetian priest, 1460; bishop, 1450; Flemish deacon, 1460. BOTTOM, LEFT TO RIGHT: Two priests with chasubles; priest with cope; English priest, 1350; priest with cope. (The priests not specifically dated above range from 1460 to 1500.)

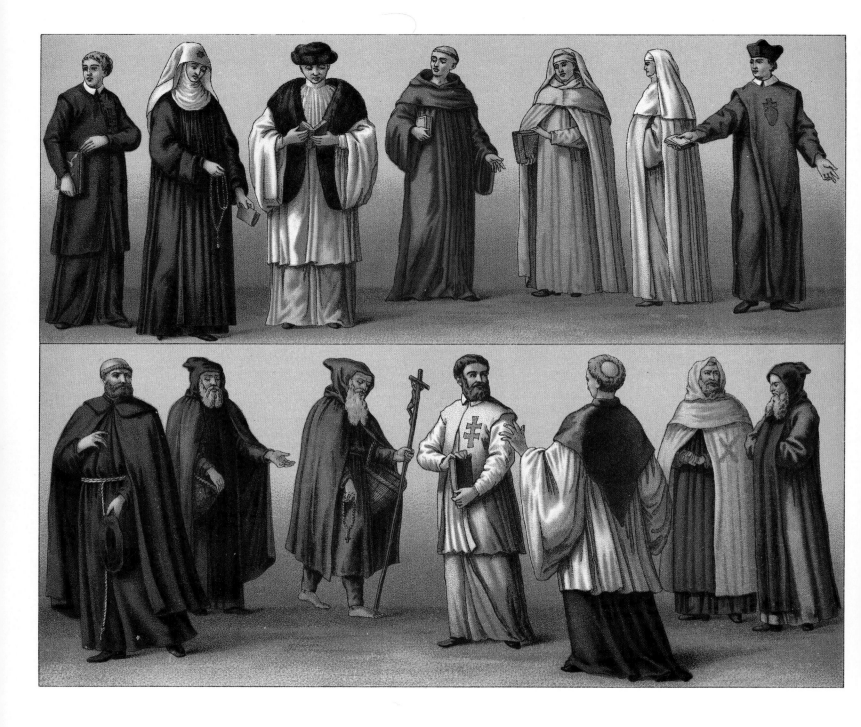

PLATE 4 · Monastic Attire, Medieval and Later.

TOP, LEFT TO RIGHT: Canon of the Holy Sepulcher, Poland, 17th century; Servite nun, Germany; Lateran canon, Poland; Slavonic monk, Poland; monk and nun of the Order of the Magdalen, Germany; canon of the Penitence of the Martyrs, Poland. BOTTOM, LEFT TO RIGHT: Franciscan penitent (*bon-fieux*), Flanders; two monks of a German and Flemish order of voluntary poverty; canon of the Holy Sepulcher, Poland, 18th century; canon of the Holy Spirit, Poland; monk of the White Brothers, Prussia; monk of a German and Flemish order of voluntary poverty.

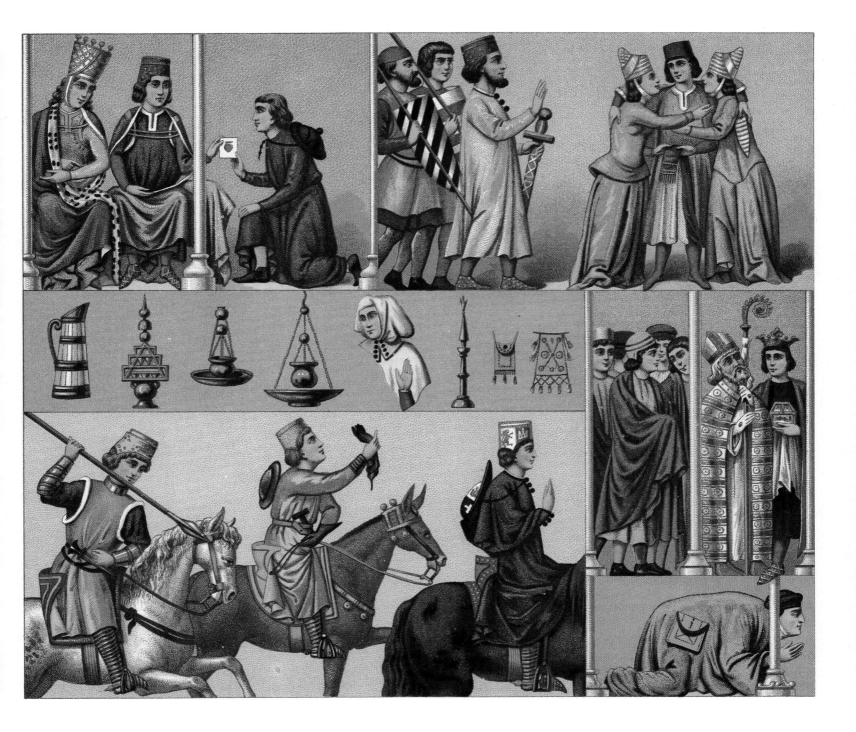

PLATE 5 · Spain, 13th Century.

From the *Cantigas* of Alfonso X "el Sabio." TOP LEFT: Noble couple and messenger. TOP RIGHT: Warriors and nobility. CENTRAL BAND: Pitcher, three lamps, secular hood, candlestick and snuffer, two alms purses. BOTTOM LEFT: Hunter, falconer, Alfonso in riding dress. BOTTOM RIGHT: Alfonso and bishop leading a procession; below, a townsman in suppliant posture.

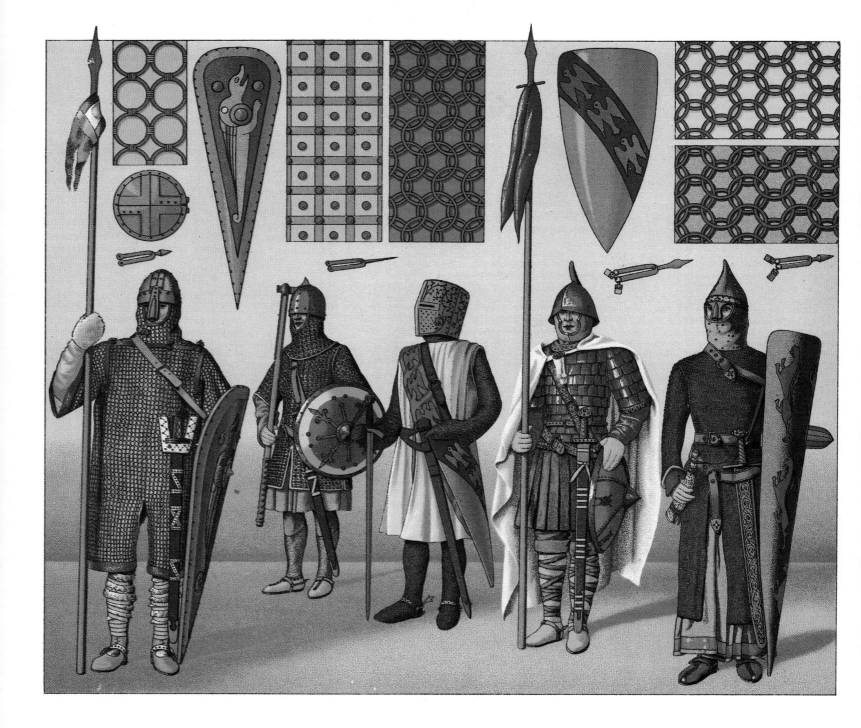

PLATE 6 · France, Battle Dress, 9th Through 13th Centuries.

FULL-LENGTH FIGURES, LEFT TO RIGHT: Reign of Philippe I, 11th century; reign of Hugues Capet, 10th century; early in reign of Louis IX, 13th century; reign of Charlemagne, 9th century; reign of Louis VI, 12th century. ABOVE: Shields, spurs, details of chain mail.

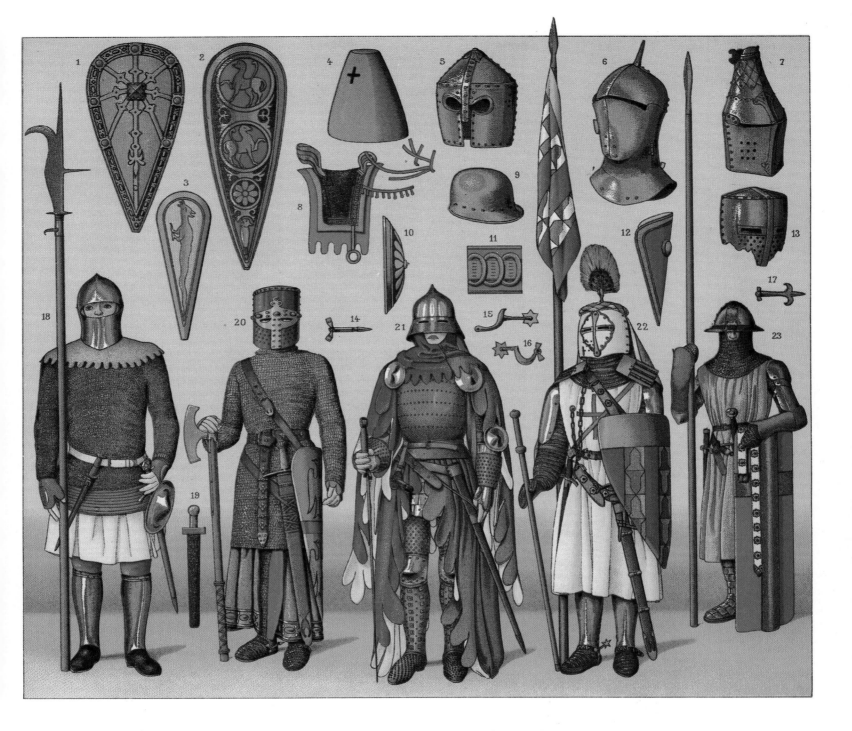

PLATE 7 · Battle Dress and Armaments, Chiefly French, 11th through 15th Centuries.

1–3, 10, 12: Shields of the 12th century. 4: Copper helmet, late 11th century. 5: English helm, late 12th or early 13th century. 6: English armet, late 15th century. 7: Jousting helm, 14th century. 8: Saddle, 12th century. 9: Sallet, 15th century. 11, 14–17: Details of costumes 18 and 20–23. 13: Bassinet, 13th century. 18: Footsoldier, ca. 1350, armed with fauchard, short sword and long dagger. 19: Short sword, 12th century. 20: Knight, late 12th century, armed with a battle-ax. 21: Chief of Parisian city militia, ca. 1350. 22: Knight-banneret, late 13th or early 14th century, setting out for the Holy Land. 23: Knight, second quarter of 14th century, armed with a lance.

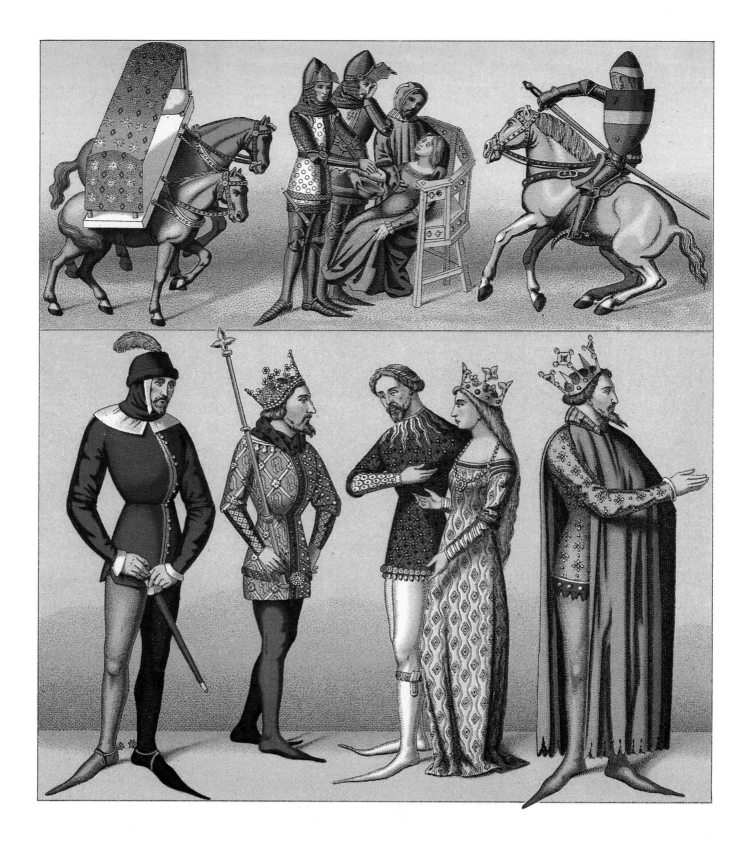

PLATE 8 · Civil and Military Attire, 14th Century.

From an Italian Arthurian manuscript.

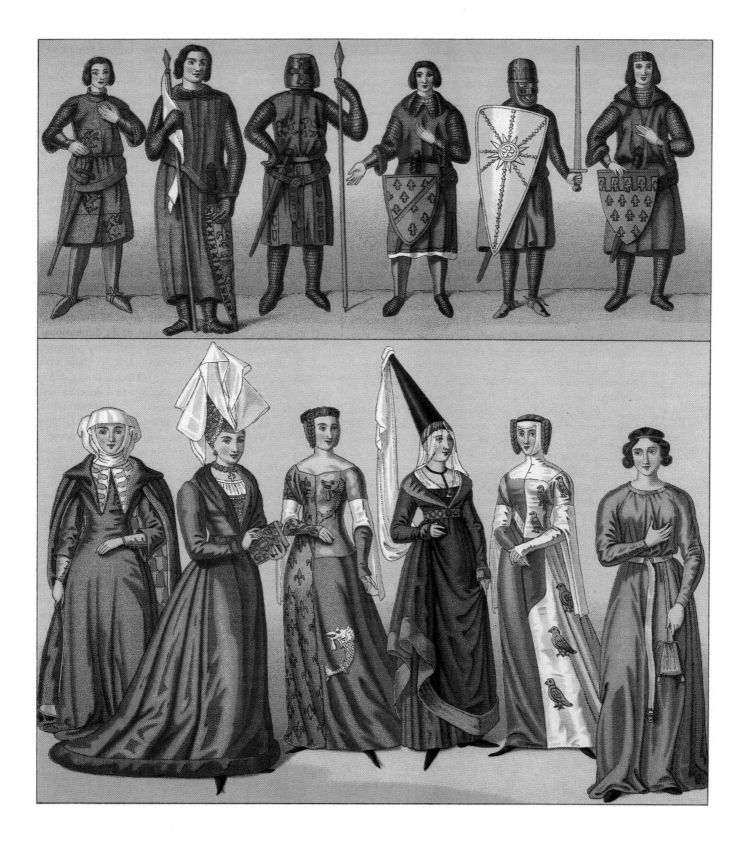

PLATE 9 · French Royalty and Nobility, 12th Through 14th Centuries.

TOP, LEFT TO RIGHT: Jakennes Loucart, knight; Eudes, Count of Chartres, 13th century; Hugues, Vidame of Châlons, 13th century; Louis of France, younger son of Philippe III, died 1319; warrior of Brabant, early 13th century; Philippe d'Artois, 13th century. BOTTOM, LEFT TO RIGHT: Marguerite de Beaujeu, 14th century; 14th century; Anne, Dauphine of Auvergne, died 1416; Jeanne of Flanders, 14th century; lady-in-waiting of Anne of Auvergne; Héloïse, 12th century.

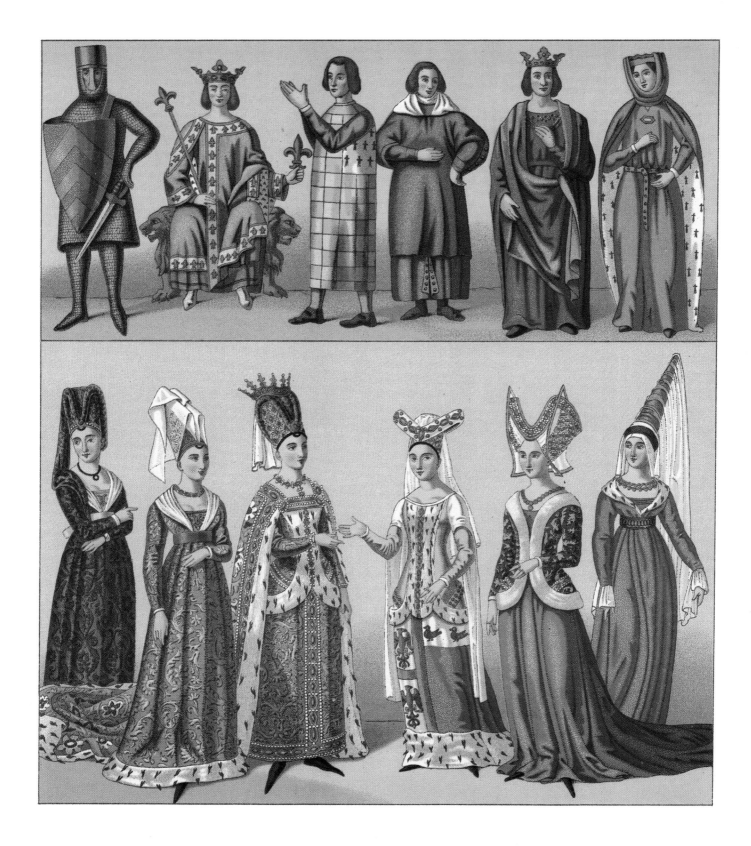

PLATE 10 · French Royalty and Nobility, 13th Through 15th Centuries.

TOP, LEFT TO RIGHT: Raoul de Beaumont, early 13th century; Philippe III, 13th century; Jean I, Count of Brittany, 13th century; Pierre de Carville, 14th century; Philippe IV, died 1314; Yolande de Montaigue. BOTTOM, LEFT TO RIGHT: Two ladies-in-waiting of Isabel of Bavaria; Isabel of Bavaria, wife of Charles VI, 14th century; Jacqueline de la Grange, 14th century; lady of the des Ursins family; Euriant, wife of the Count of Nevers, early 15th century.

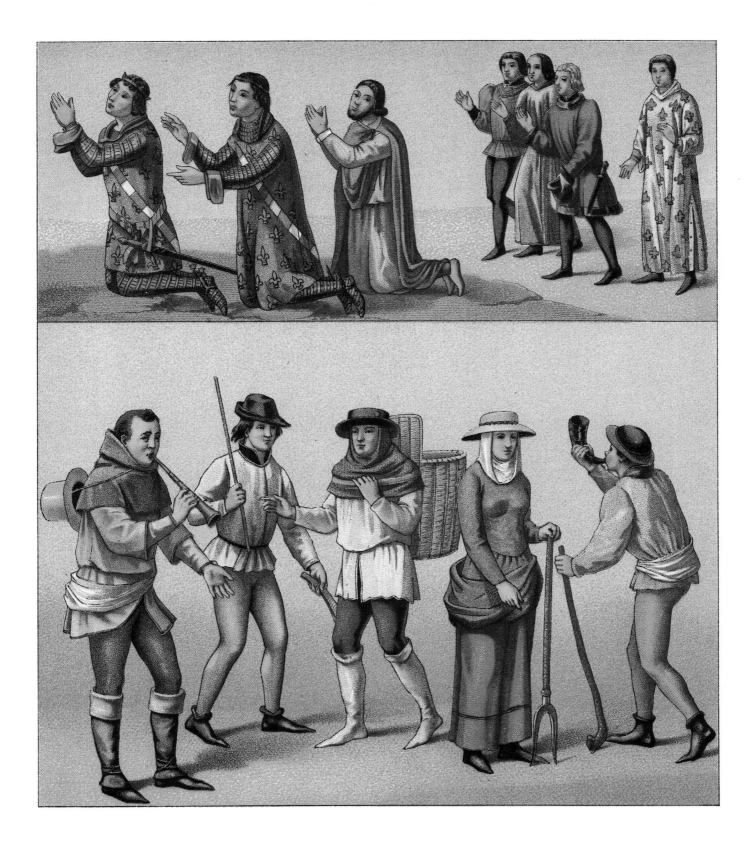

PLATE 11 · France, 13th and 14th Centuries.

TOP, LEFT TO RIGHT: Philippe, Count of Evreux, 14th century; his father, Louis of France, died 1319; Raoul de Courtenai, 13th century; three townsmen, 14th century; Louis, son of Louis IX, 13th century. BOTTOM, LEFT TO RIGHT (all of reign of Charles V, 14th century): Peasant, laborer, vintager, woman gardener, cowherd.

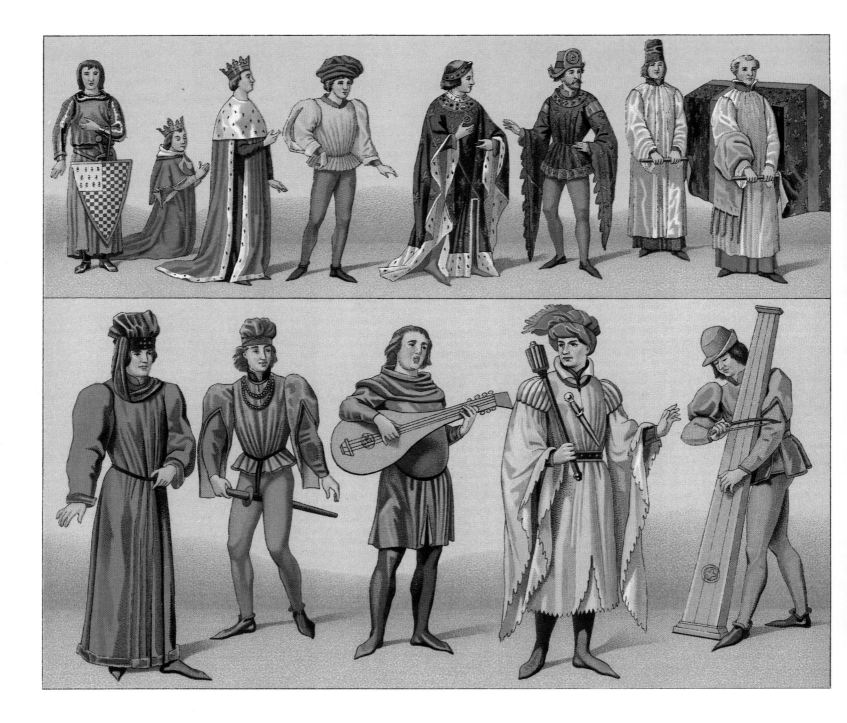

PLATE 12 · France, 13th Through 15th Centuries.

TOP, LEFT TO RIGHT, STANDING: Pierre de Dreux, knight, 13th century; Jean II, 14th century; François I, Duke of Brittany, 15th century, in everyday dress; the same in full ducal garb; Louis I, Duke of Bourbon, 14th century; Jean, Duke of Bourbon, 15th century; clergyman, 14th century. BOTTOM, LEFT TO RIGHT: Duke of Cologne, 14th century; courtier of Charles V, 14th century; lute player; sergeant at arms, ca. 1400; dichord player.

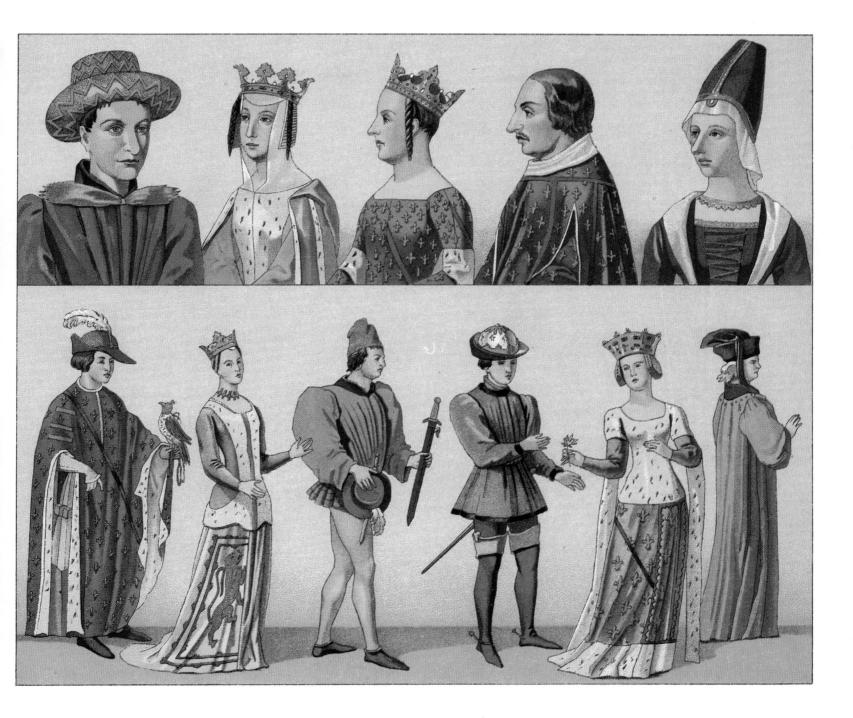

PLATE 13 · French Royalty and Nobility, 14th and 15th Centuries.

TOP, LEFT TO RIGHT: Charles VII, 15th century; Béatrix de Bourbon, 14th century; Jeanne de Bourbon, wife of Charles V, 14th century; Louis de France, Duke of Anjou, 14th century; Marie of Anjou, wife of Charles VII, 15th century. BOTTOM, LEFT TO RIGHT: Duke of Bourbon, 14th century; Isabelle Stuart, Duchess of Brittany, 15th century; master of the horse of a duke of Brittany, 15th century; Charles VII; Marie Berri, Duchess of Bourbon, 15th century; doctor at the court of Charles VII.

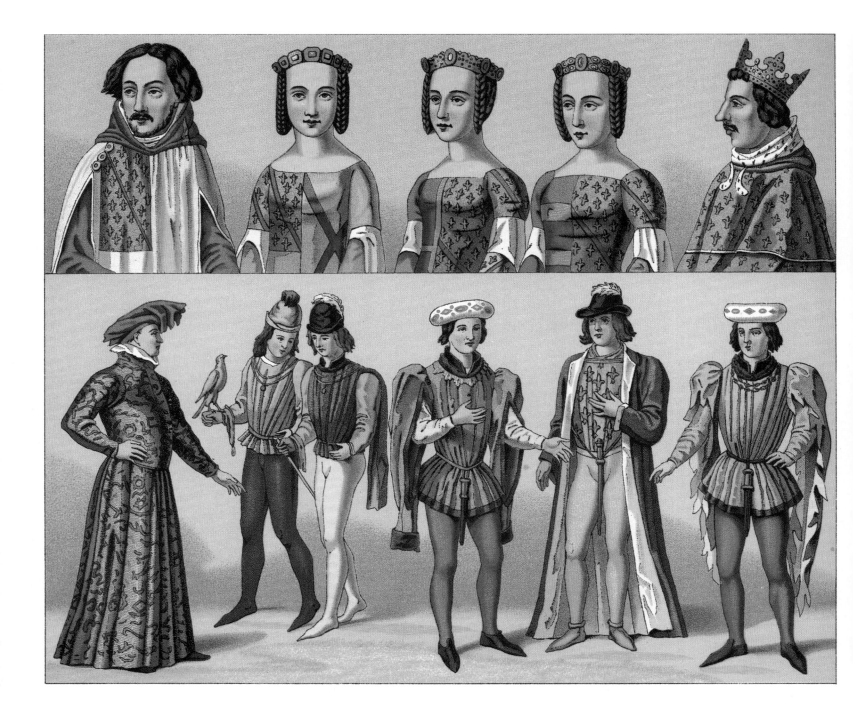

PLATE 14 · French Royalty and Nobility, 14th and 15th Centuries.

TOP, LEFT TO RIGHT (all 14th century): Jean, bastard of Bourbon; Agnès de Chaleu, his wife; Bonne de Bourbon, Countess of Savoie; Marguerite de Bourbon; Charles V. BOTTOM, LEFT TO RIGHT: Louis II, King of Naples, died 1417; two courtiers of Charles VII, 15th century; Jean de Montagu, died 1409; Charles I, Duke of Bourbon; Charles de Montagu, son of the preceding, died 1415.

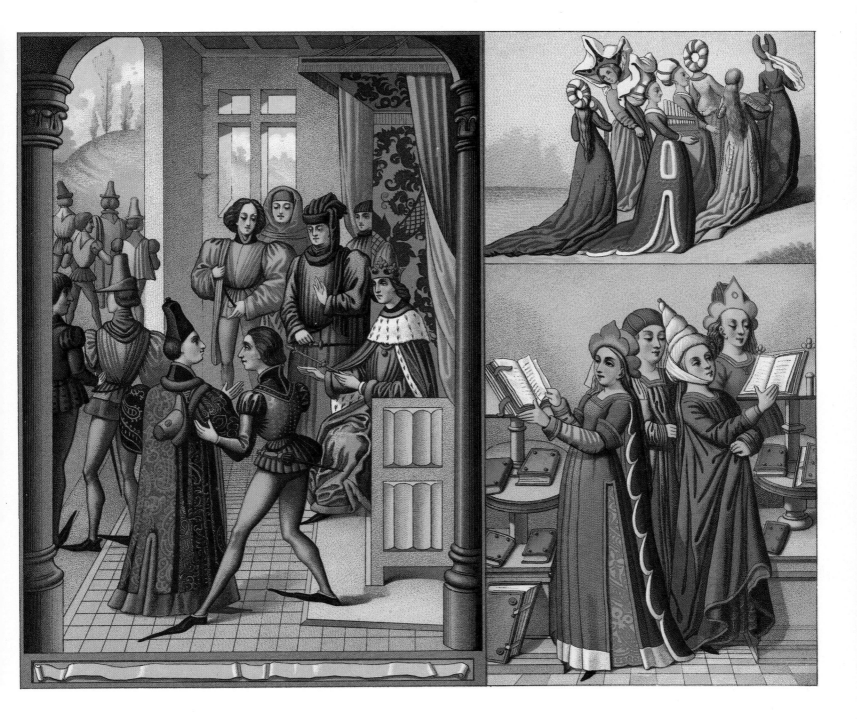

PLATE 15 · France, 15th Century.

LEFT: Royal court scene. RIGHT: Two groups showing female dress.

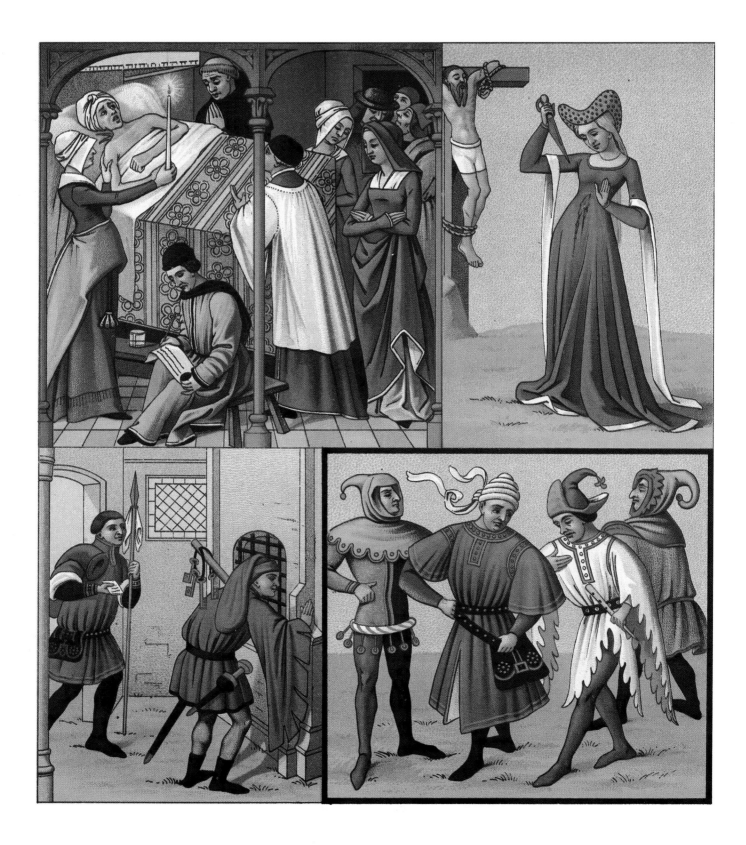

PLATE 16 · France, 14th and 15th Centuries.

TOP, LEFT TO RIGHT: Deathbed scene, 15th century; Lucrece dressed as a 14th-century lady.
BOTTOM, LEFT TO RIGHT: Messenger and turnkey, 14th century; various 14th-century costumes.

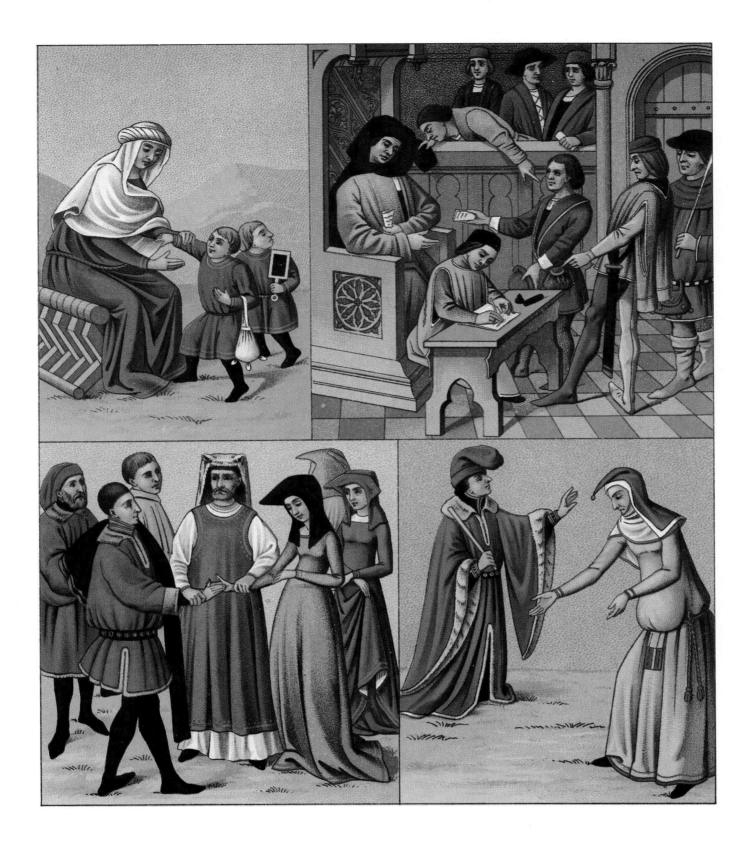

PLATE 17 · France, 15th Century.

TOP, LEFT TO RIGHT: Seated lady and children; courtroom scene. BOTTOM, LEFT TO RIGHT: Marriage scene; man and widow.

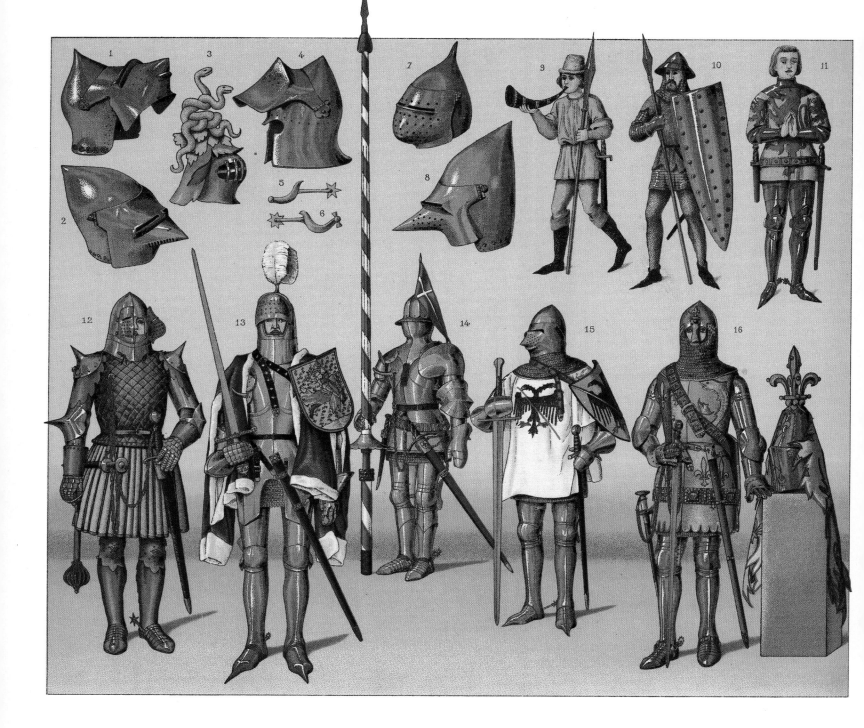

PLATE 18 · Battle Dress, Chiefly French, 14th and 15th Centuries.

1, 2, 4, 7, 8: Bassinets (4 & 7 are English). **3:** Italian armet, 15th century. **5, 6:** Spurs. **9:** Infantry trumpeter. **10:** Footsoldier with body shield (pavis), 14th century. **11:** Nobleman, ca. 1400. **12:** Knight, second half of 14th century. **13:** Charles d'Orléans, 15th century. **14:** Knight, early 15th century. **15:** Knight, 14th century. **16:** Armor of Charles V while still dauphin, 14th century.

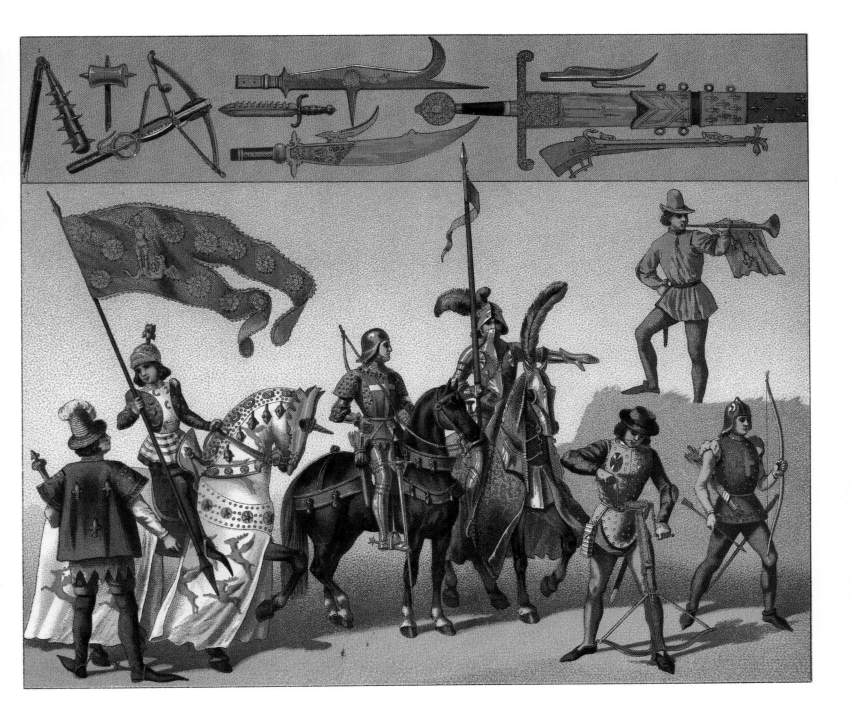

PLATE 19 · French Battle Dress and Weapons, 15th Century.

FIGURES, LEFT TO RIGHT: Herald; page with royal standard; mounted bowman; member of the first French regular troops, the *compagnies d'ordonnance*; trumpeter; crossbowman; bowman on foot.

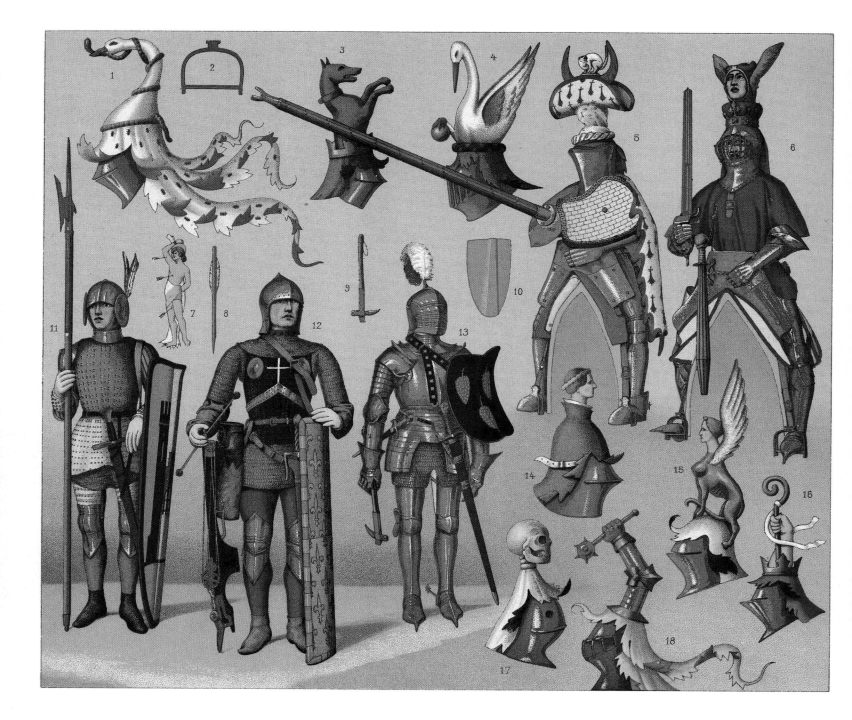

PLATE 20 · Battle, Joust and Tournament Dress, France, 15th Century.

1, 3, 4, 14–18: Fanciful crests. 2: Stirrup. 5: Knight armed for a joust (single combat with lance). 6: Knight armed for a tournament (combat between troupes). 7: Symbol of Saint Sebastian from a crossbowman's shield. 8: Crossbowman. 9: Martel-de-fer. 10: Pavis. 11: Infantryman. 12: Crossbowman. 13: Knight.

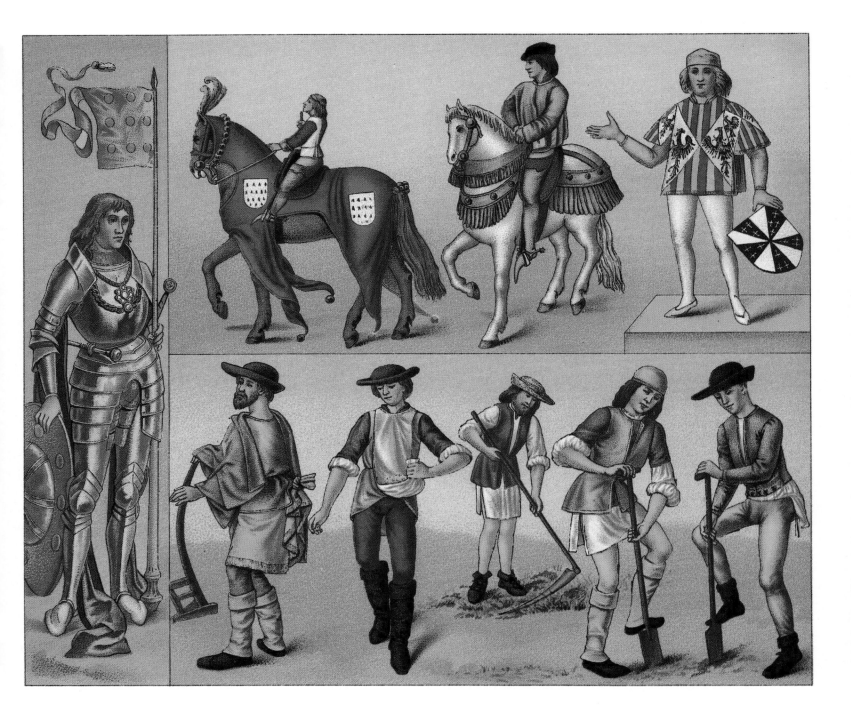

PLATE 21 · Western Europe, 15th Century.

LEFT: Knight-banneret in gilded armor. UPPER BAND: Page in livery with tournament horse; duke of Brittany as a tournament official; herald of Alfonso of Aragon. LOWER BAND: Ploughman; sower; reaper; two gravediggers.

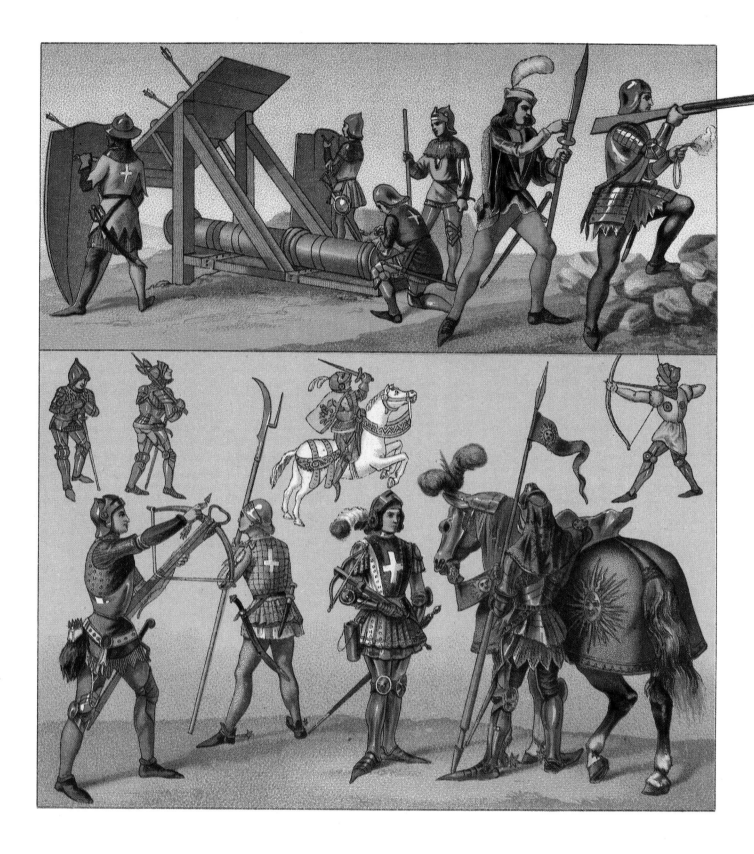

PLATE 22 · Military Garb, France, 15th Century.

TOP: Artilleryman. SMALL FIGURES: Light cavalryman and three footsoldiers with various arms. BOTTOM ROW: Infantry crossbowman; infantryman armed with a vouge; crossbowman and lancer of the mounted guard of Charles VII.

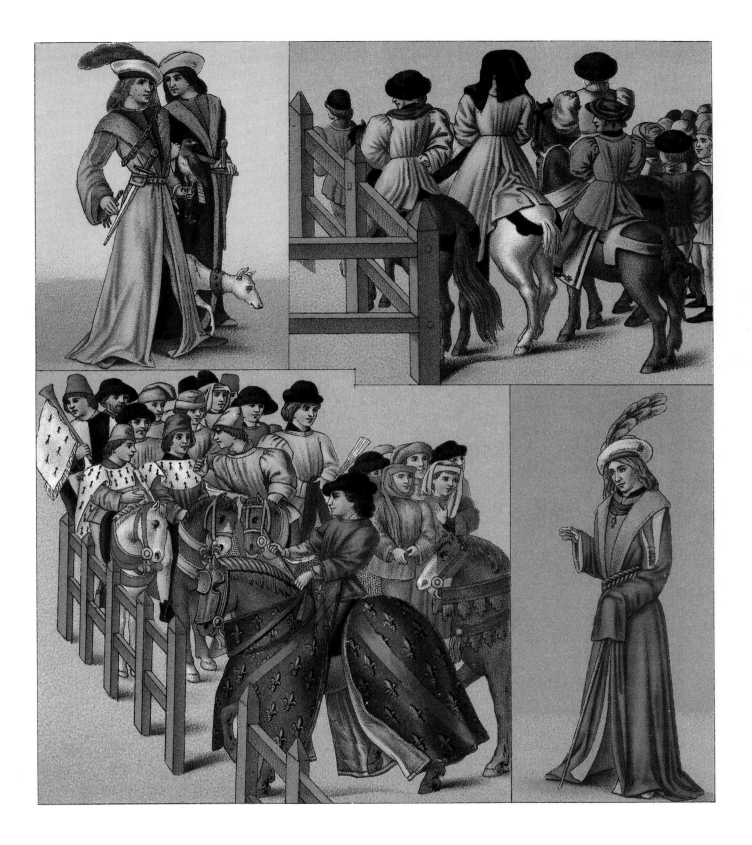

PLATE 23 · France, 15th Century.

SMALLER CORNERS: Fashionable gentlemen of the 1480s. LARGER CORNERS: Participants in a tournament, ca. 1450.

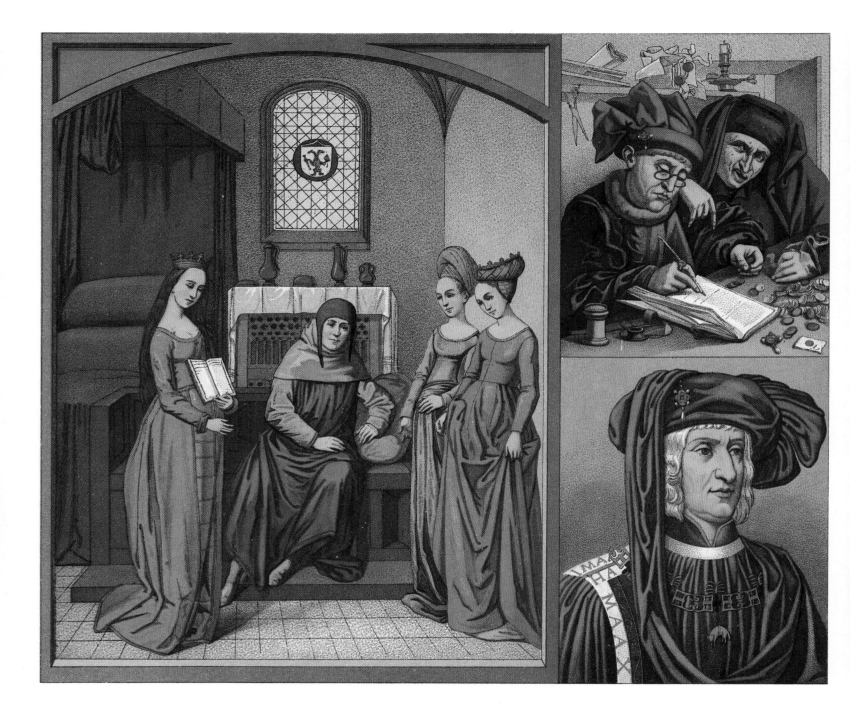

PLATE 24 · Europe, 15th Century.

LEFT: Flemish group. UPPER RIGHT: Money changers of Antwerp. LOWER RIGHT: Holy Roman Emperor Maximilian I as a Knight of the Golden Fleece.

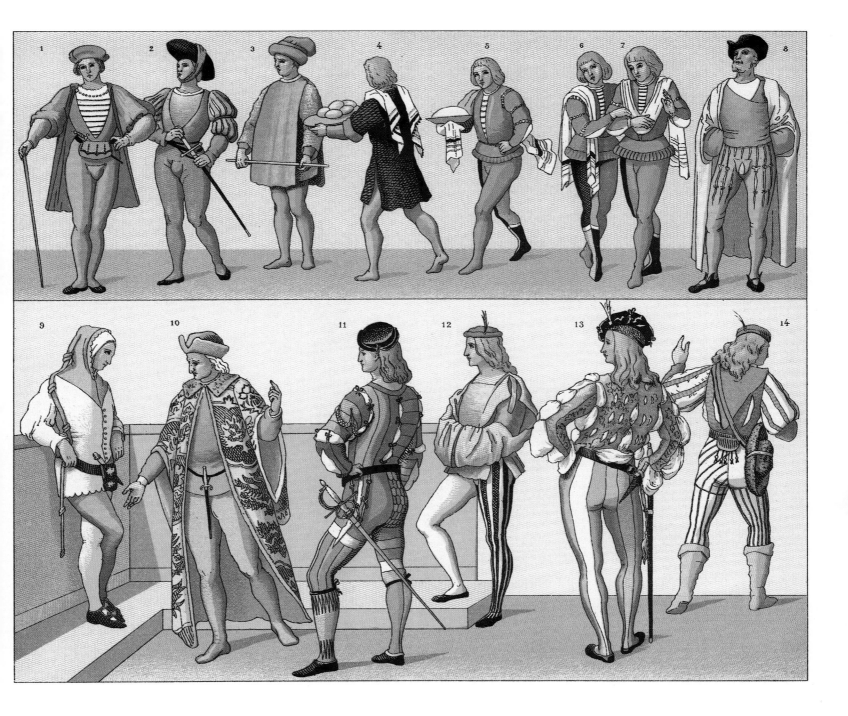

PLATE 25 · Italy (Chiefly), 14th Through 16th Centuries.

1: Papal officer, 15th century. 2: Gentleman, 15th century. 3: Officer in livery, late 14th century. 4–7: Pages, 15th century. 8: Venetian nobleman in winter clothing, late 15th century. 9: Gentleman, late 14th century. 10: Flemish nobleman, 15th century. 11: Officer in parade dress, early 16th century. 12: Venetian gentleman, 15th century. 13: Minion, early 16th century. 14: Venetian condottiere, 16th century.

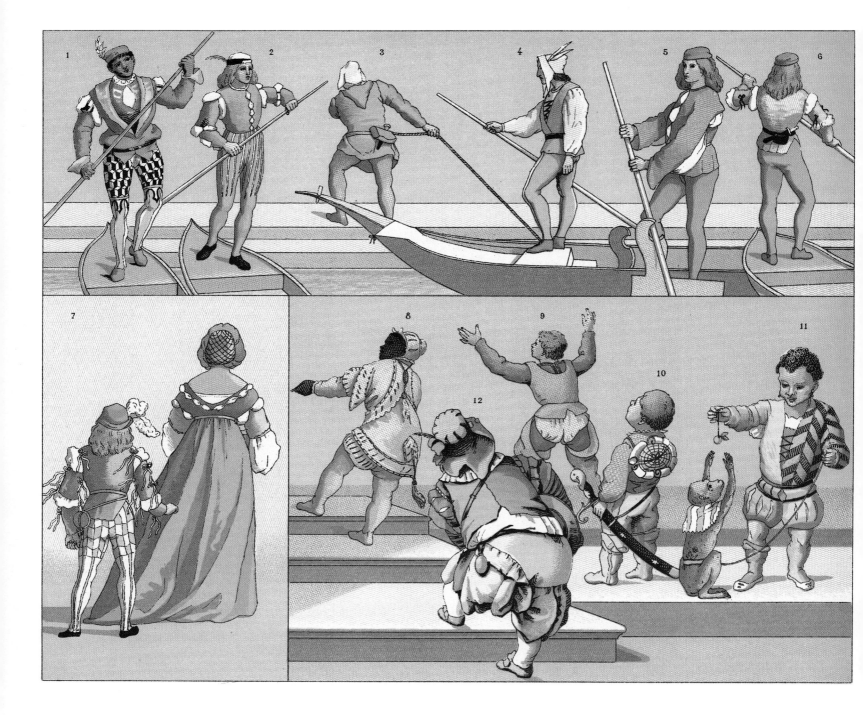

PLATE 26 · Italy, 14th Through 18th Centuries.

1–6: Gondoliers, late 15th and early 16th centuries. 7: Noblewoman with page, 15th century. 8, 10–12: Dwarfs and court fools (all 16th-century, except 12, which is 18th). 9: Page in riding costume, 14th century.

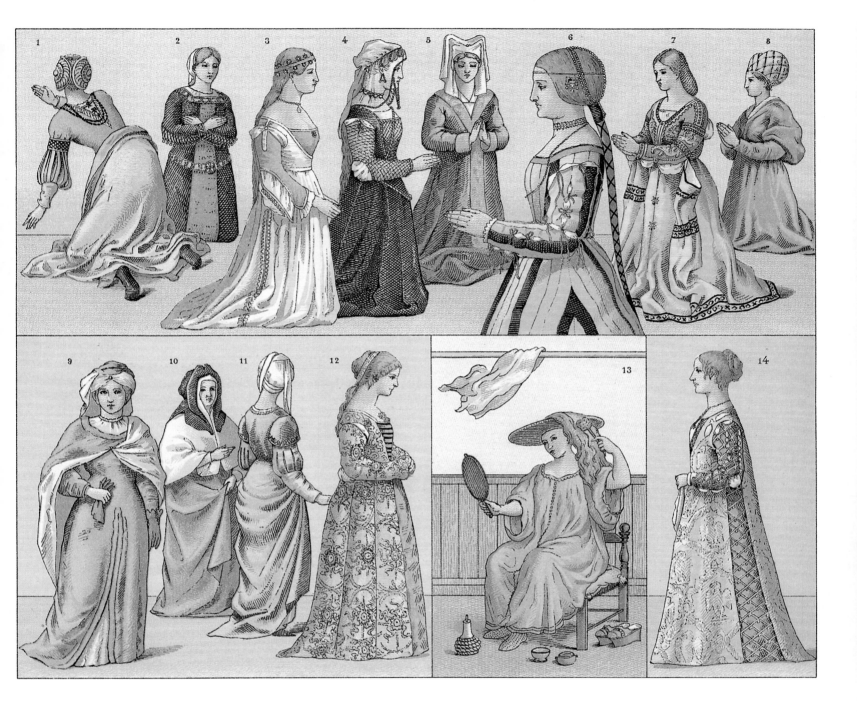

PLATE 27 · Italy (Chiefly), 14th Through 16th Centuries.

1: Dutch noblewoman, 15th century. 2: Italian noblewoman, 14th century. 3: Venetian girl, 15th century. 4: Venetian bride, 15th century. 5: Italian noblewoman, 14th century. 6: Italian noblewoman, 15th century. 7: Venetian noblewoman, early 16th century. 8: Italian noblewoman, 15th century. 9: Roman lady, 14th century. 10 & 11: Dutch noblewoman and her servant, 15th century. 12: Italian girl of the nobility, late 15th century. 13: Venetian lady bleaching her hair, 16th century. 14: Italian noblewoman, late 15th century.

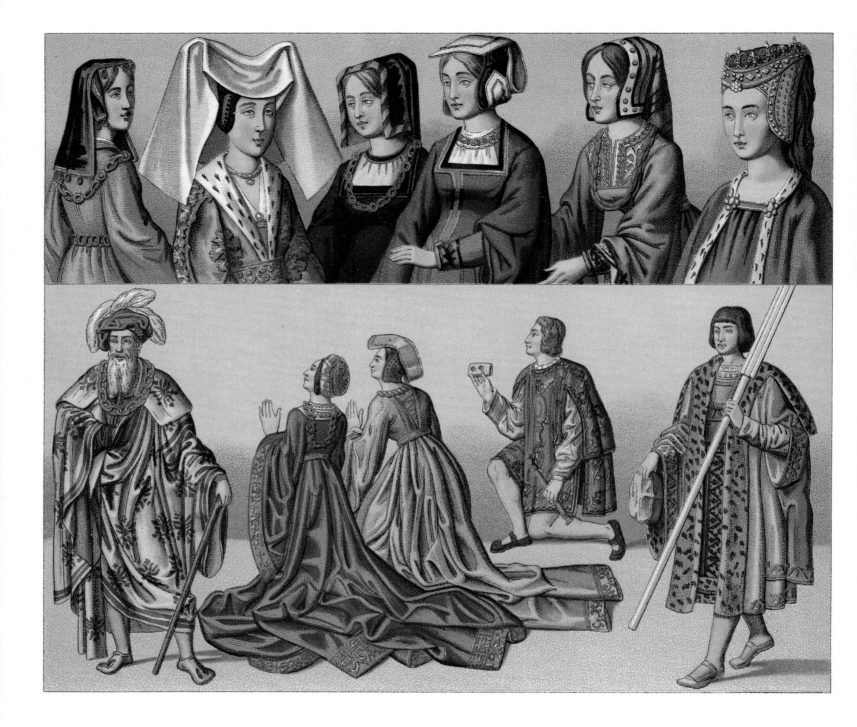

PLATE 28 · France (Chiefly), Late 15th and Early 16th Centuries.

TOP, LEFT TO RIGHT: Woman with hood; Jeanne de France, first wife of Louis XII; three figures from tapestries; Catherine of Aragon, first wife of Henry VIII of England. BOTTOM, LEFT TO RIGHT: Man in mantle; two figures from tapestries; messenger wearing a tabard; man carrying a festival torch.

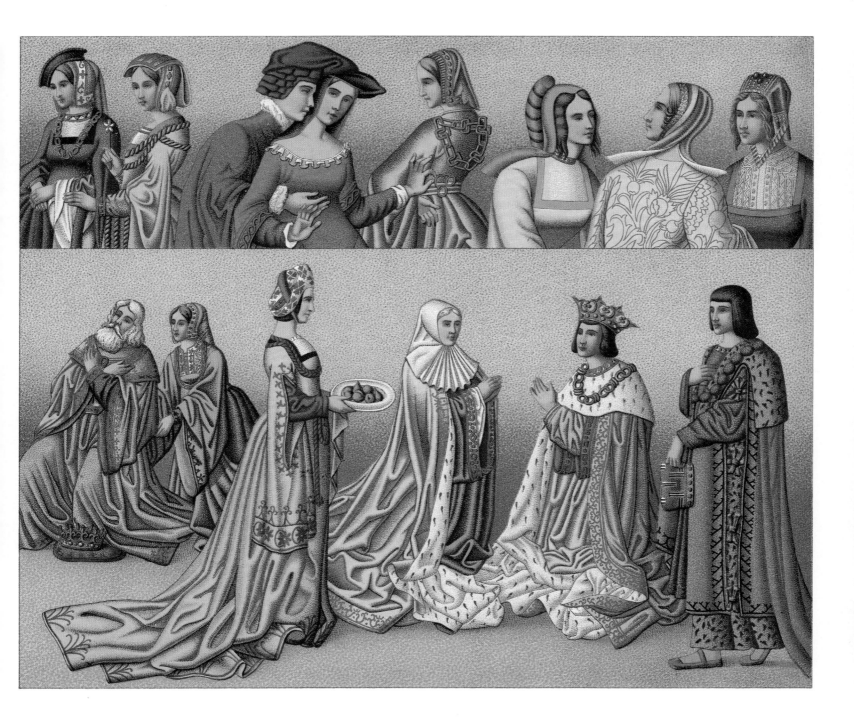

PLATE 29 · Western Europe, Late 15th and Early 16th Centuries.

Costumes of the nobility in a transitional period in which French dress absorbed influences from both Italy and Flanders.

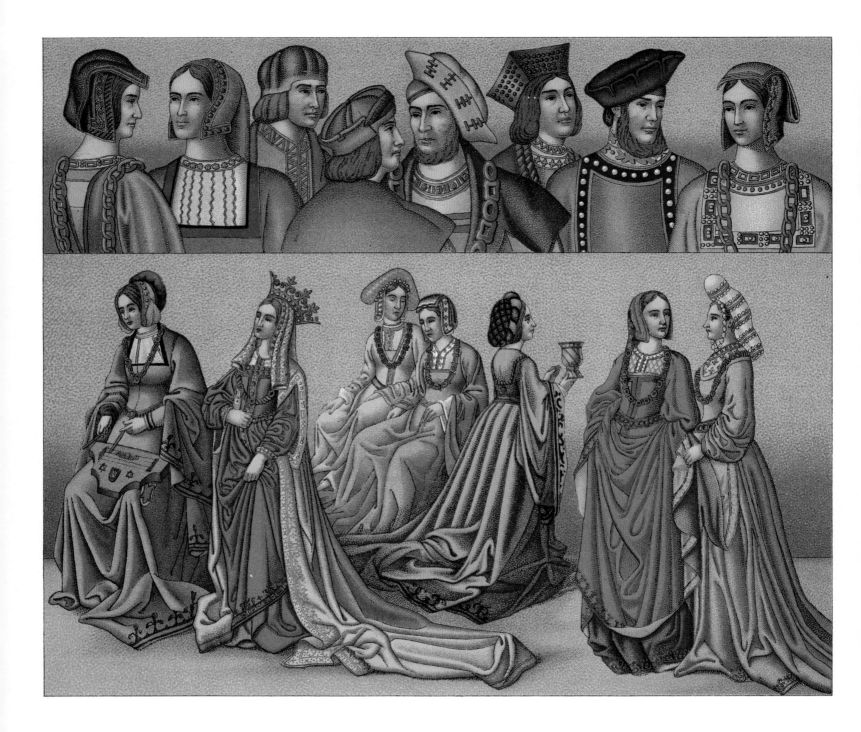

PLATE 30 · France and Flanders, Late 15th Century.

From tapestries of the reign of Louis XII.

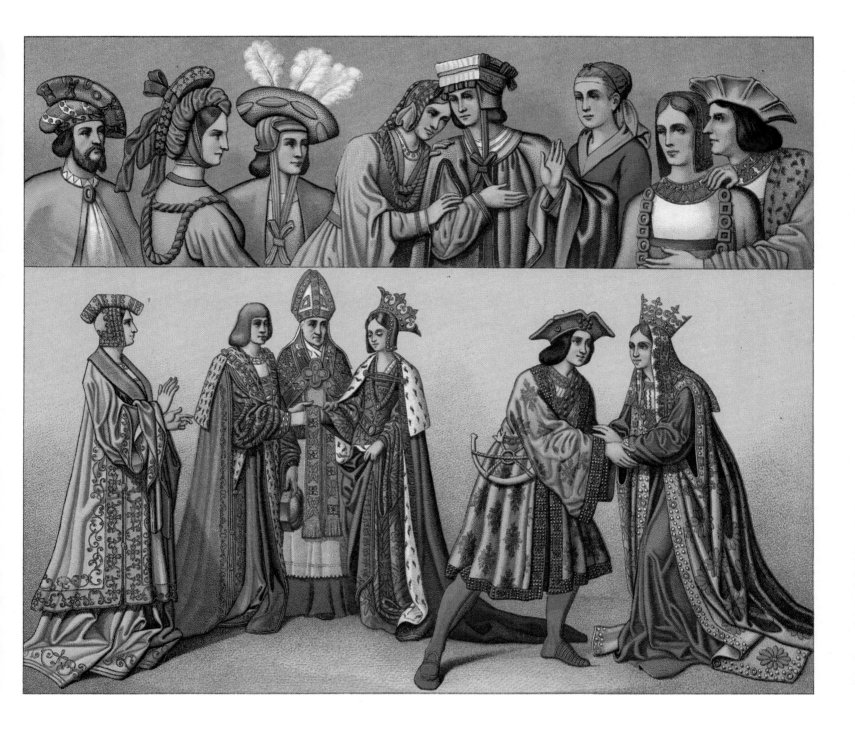

PLATE 31 · France and Flanders, Late 15th Century.

From tapestries of the reign of Louis XII.

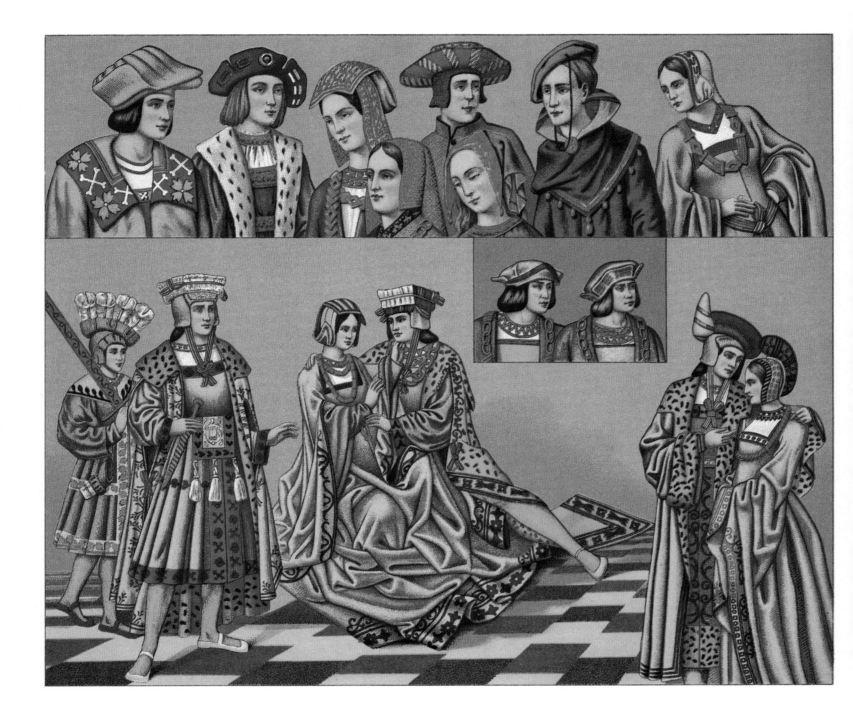

PLATE 32 · Western Europe, Late 15th and Early 16th Centuries.

Elegant costumes including the surcoat for women, the mantle for men and a variety of headgear.

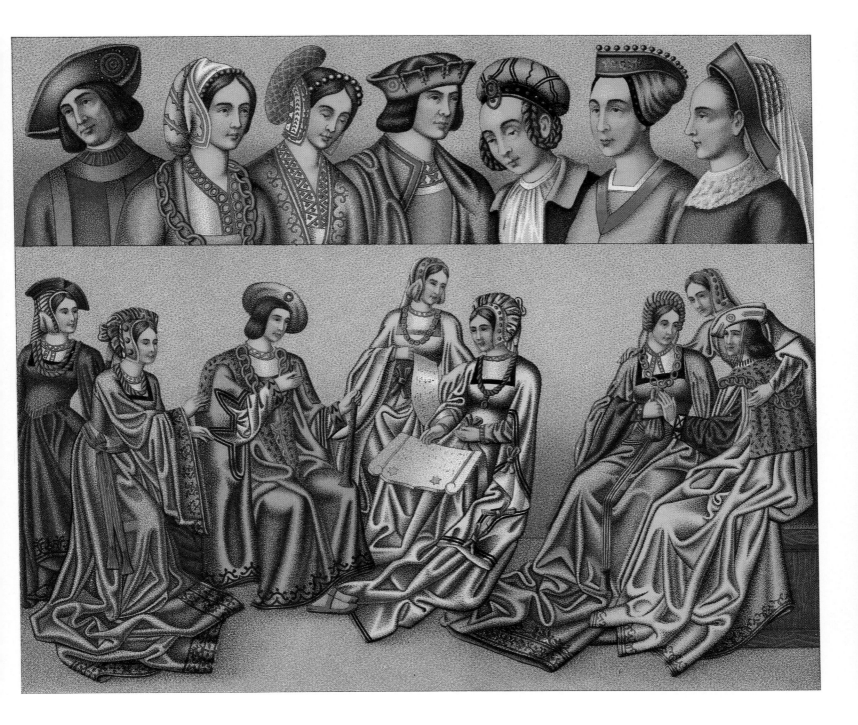

PLATE 33 · Western Europe, Late 15th and Early 16th Centuries.

Elegant costumes including the surcoat for women, the mantle for men and a variety of headgear.

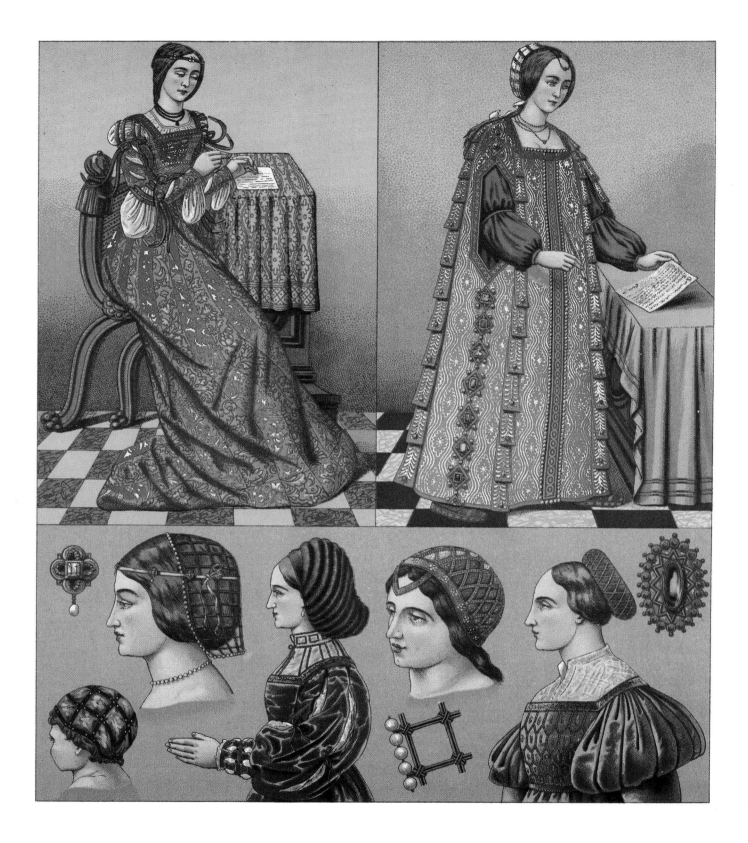

PLATE 34 · Women's Attire, Chiefly Italy, 16th Century.

TOP LEFT: Milanese lady. TOP RIGHT: Girl of the nobility. BOTTOM: Variety of headgear and jewelry.

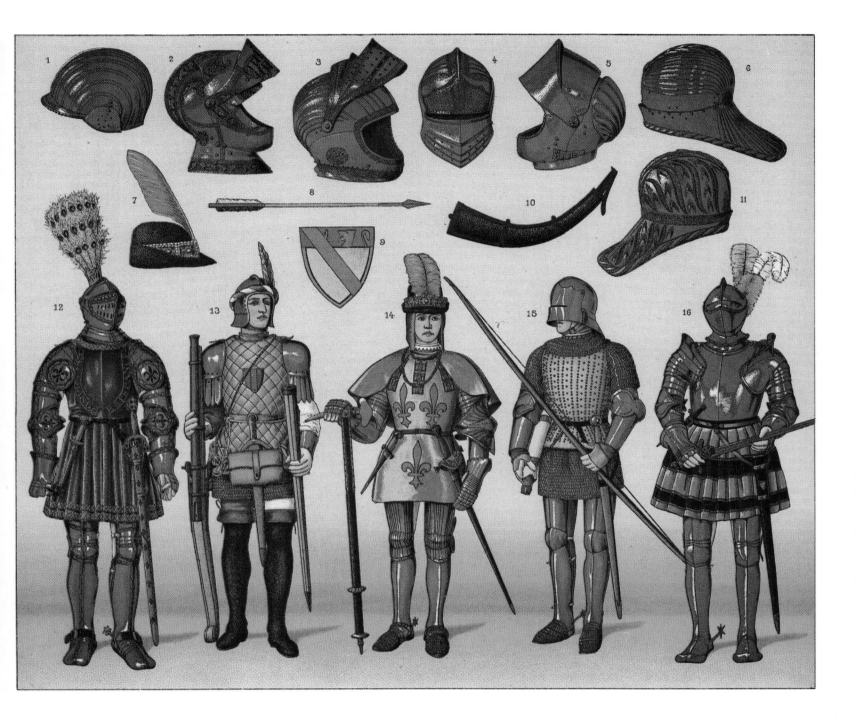

PLATE 35 · Battle and Jousting Dress, 15th and 16th Centuries.

1: Cabasset, 16th century. 2: Armet, first half of 16th century. 3: Large Maximilian armet, early 16th century. 4: Sallet, ca. 1500. 5: Single armet, turn of 16th century. 6: Tournament sallet, German, turn of 16th century. 7: Cap belonging to No. 14. 8: Arrow belonging to no. 15. 9: Coat of arms of Bayard decorating the sword sheath of no. 16. 10: Powder horn belonging to no. 13. 11: Tournament sallet, German, early 16th century. 12: French knight, early 16th century. 13: French culverineer, late 15th century. 14: Armor of the high French nobility, late 15th century. 15: French mounted bowman, 15th century. 16: French knight, reign of François I, 16th century.

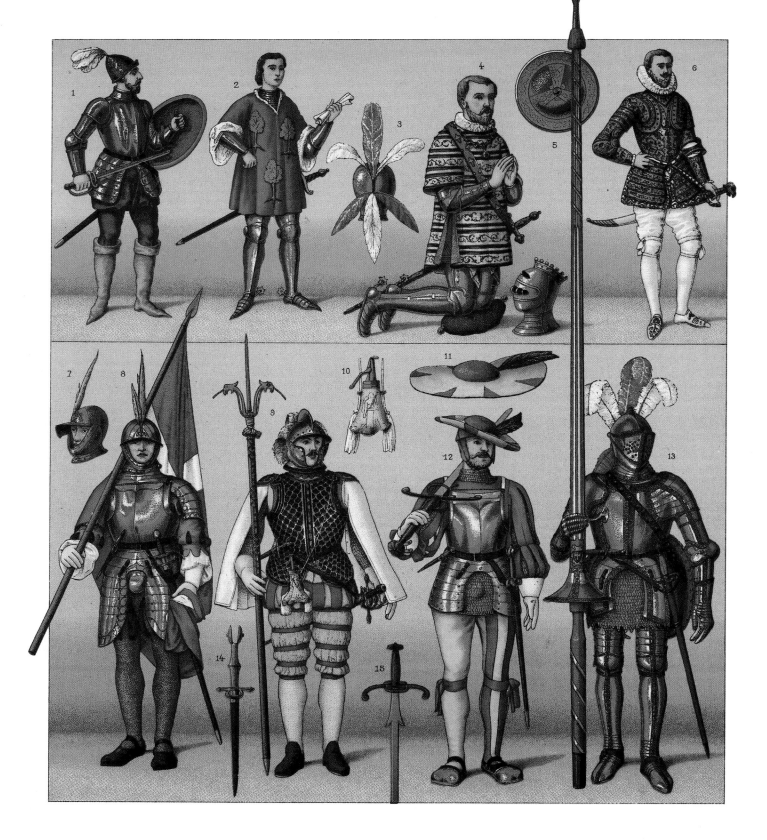

PLATE 36 · French Military Dress, 15th and 16th Centuries.

1: Reign of Charles IX (1560–1574). **2:** Reign of Louis XI (1461–1483). **3:** Helmet plume arrangement of no. 13. **4:** Reigns of François I (1515–1547) and Henri II (1547–1559). **5:** Rondache belonging to no. 13. **6:** Reign of Henri III (1574–1589). **7:** Side view of helmet in no. 8. **8:** End of reign of François I. **9:** Artillery captain, reign of Henri II. **10:** Powder horn belonging to no. 9. **11:** Hat belonging to no. 12. **12:** Swiss soldier in French service, reign of François I. **13:** Reign of Henri II. **14:** Dagger belonging to no. 9. **15:** Sword belonging to no. 12.

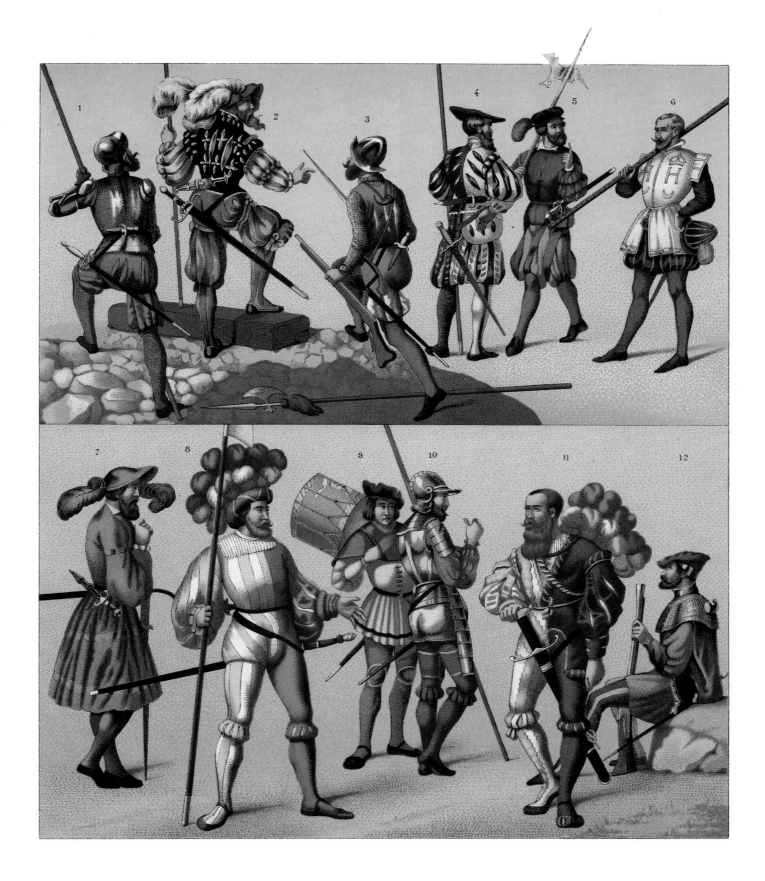

PLATE 37 · French Native and Mercenary Military Costume, 16th Century.

1: Pikeman, French regular infantry, 1548. 2: Swiss captain, 1550. 3: Arquebusier, French infantry, 1548. 4: Swiss guardsman, 1520. 5: Lansquenet, 1550. 6: Scottish guardsman, 1559. 7: Lansquenet captain, 1525. 8: Swiss guardsman, 1520. 9: Militia drummer, 1534. 10: Militia halberdier, 1534. 11: Swiss guard captain, 1520. 12: Militia arquebusier, 1534.

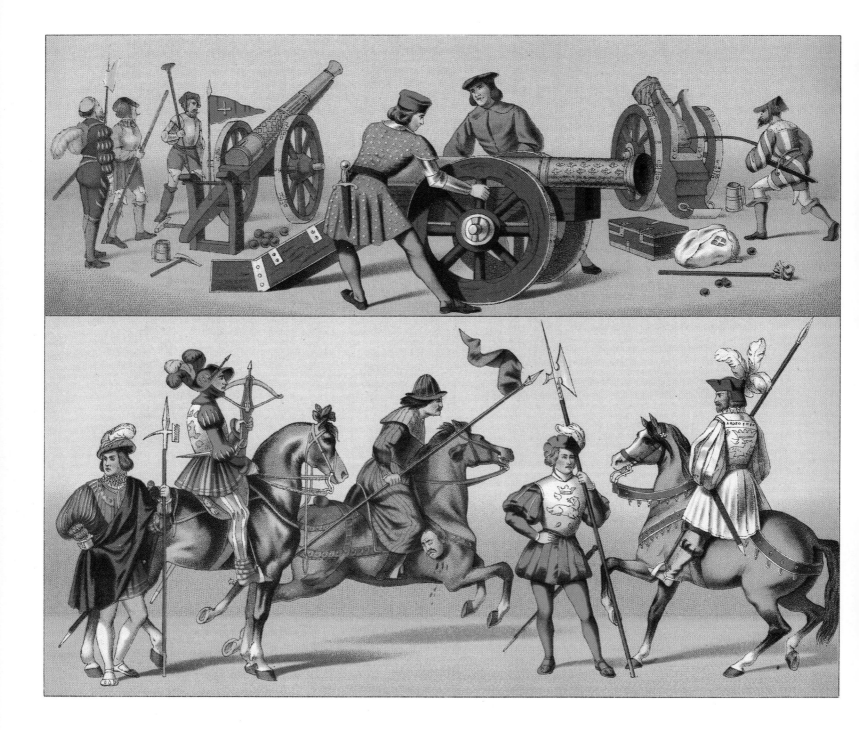

PLATE 38 · French Military Costume, Early 16th Century.

TOP: Artillerymen. BOTTOM, LEFT TO RIGHT: Royal guardsman, with the *bec de corbin* halberd; mounted crossbowman of the royal guard; stradiot; guardsman; Scottish guardsman.

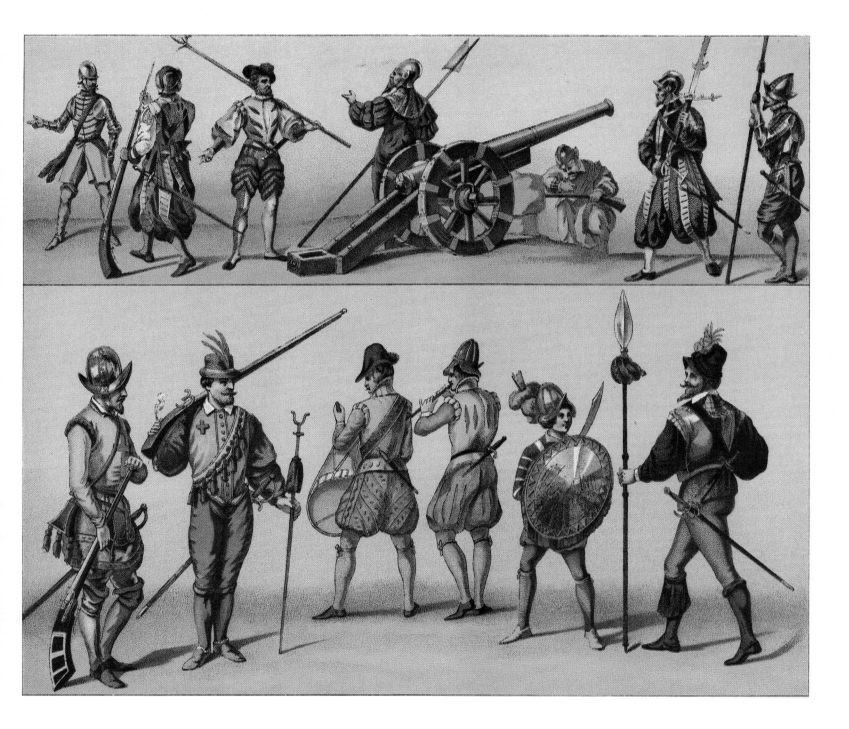

PLATE 39 · French Military Costume, Later 16th Century.

TOP, LEFT TO RIGHT: Light cavalryman, 1562; lansquenet arquebusier, 1562; Swiss artilleryman, 1559; gunner, 1559; lansquenet arquebusier, 1562; lansquenet two-handed swordsman, 1562; pikeman, 1572. BOTTOM, LEFT TO RIGHT (all 1572): Arquebusier; musketeer; drummer; fifer; lackey with cutlass, rondache and morion; captain with pike.

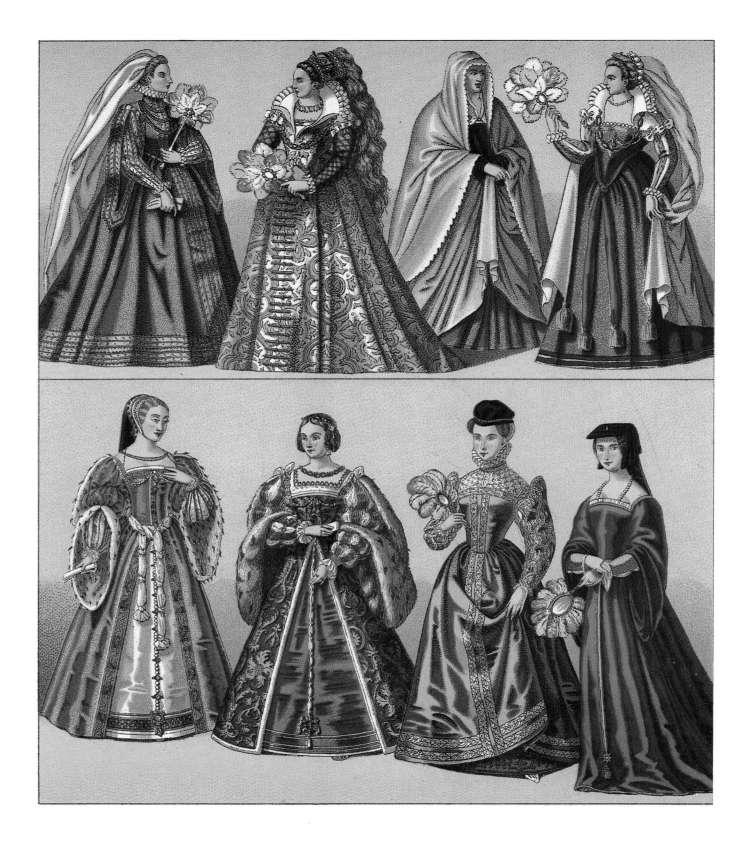

PLATE 40 · Women's Attire, Italy and France, 16th Century.

TOP ROW, LEFT TO RIGHT: Milanese girl; Venetian bride; Venetian widow; Venetian merchant's wife.
BOTTOM ROW, LEFT TO RIGHT: Diane de Poitiers; Eleanor of Castile, second wife of François I; Marguerite de France, third daughter of François I; La Belle Ferronnière, ca. 1540.

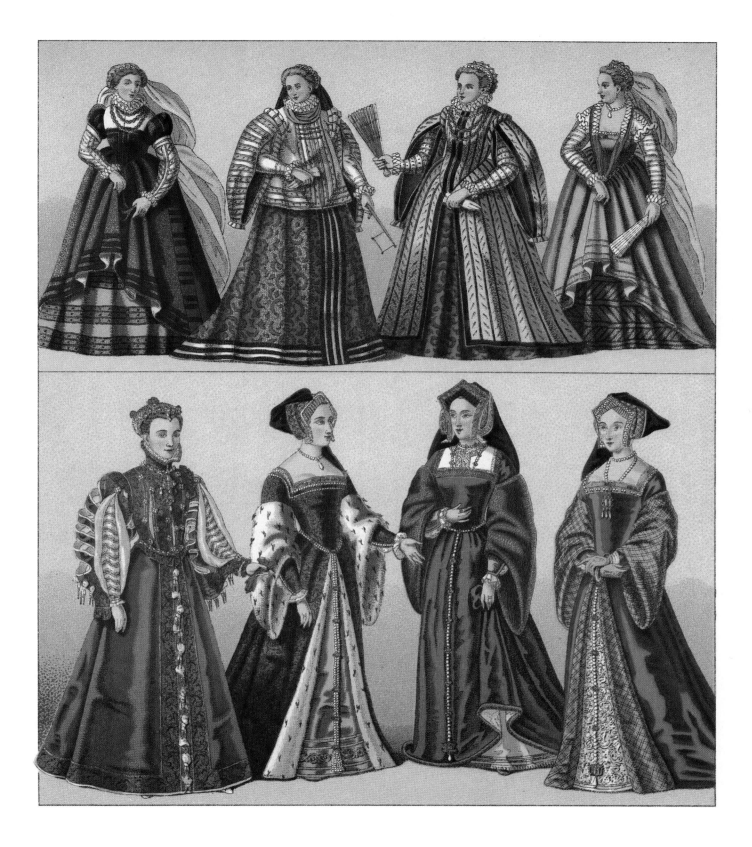

PLATE 41 · Women's Attire, Italy, France and England, 16th Century.

TOP ROW, LEFT TO RIGHT: Young noblewoman of Ravenna; Neapolitan noblewoman; Neapolitan married princess; Paduan lady. BOTTOM ROW, LEFT TO RIGHT: Elizabeth of Valois, French wife of Philip II of Spain; Anne Boleyn, second wife of Henry VIII of England; Mary of England, wife of Louis XII of France; lady-in-waiting of Mary of England.

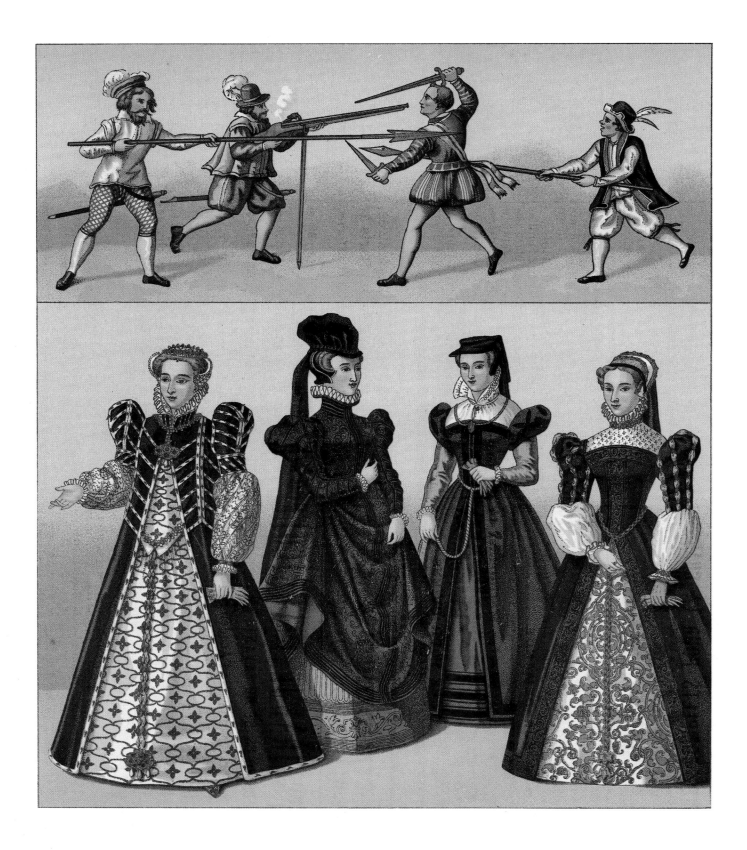

PLATE 42 · France, 16th Century.

TOP: Volunteer participants in the civil wars of the reign of Henri IV, late in the century—an infantry captain attacking a musketeer, and two pikemen. BOTTOM, LEFT TO RIGHT: Catherine de Médicis; Marie Touchet; Renée de Vieux-Châteauneuf; the Duchess of Etampes.

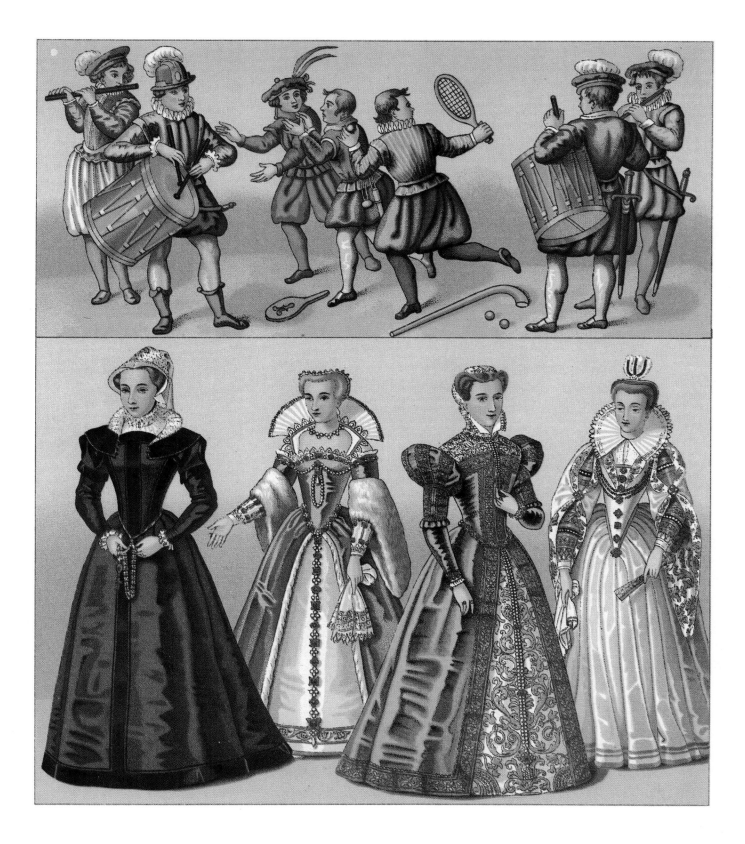

PLATE 43 · France, 16th and 17th Centuries.

TOP: Three schoolboys (early 17th century) flanked by drummers and fifers of town militia (all figures on the plate except the schoolboys are 16th-century). BOTTOM, LEFT TO RIGHT: Lady-in-waiting of Catherine de Médicis; Louise de Lorraine Vaudemont, wife of Henri III; Mary Stuart, who was the wife of François II before becoming queen of Scotland; Duchess of Joyeuse dressed for her wedding ball, 1581.

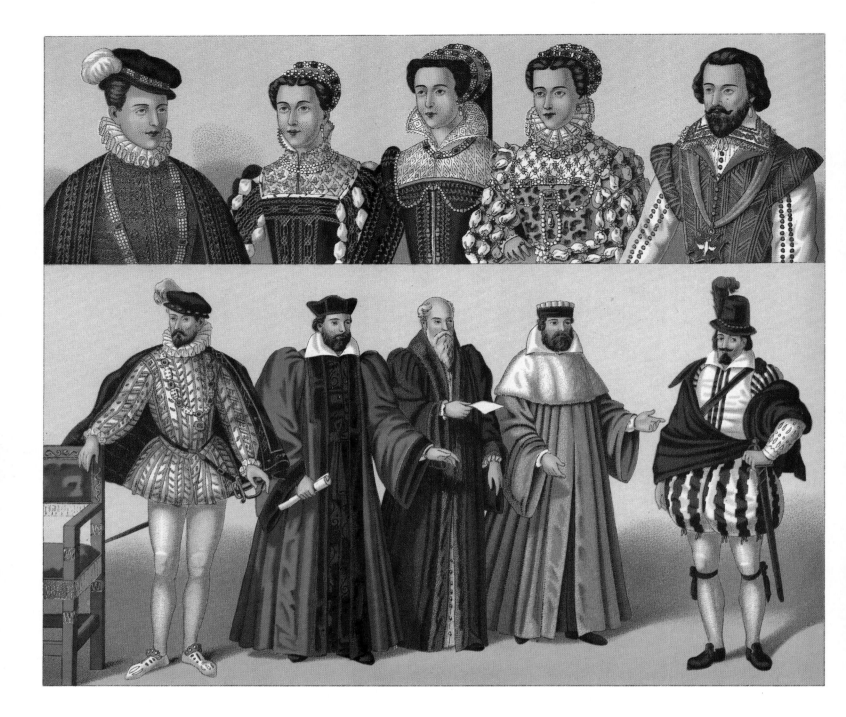

PLATE 44 · Royalty, Nobility and Magistrates, France, 16th Century.

TOP, LEFT TO RIGHT: Duke of Anjou; Duchess of Montpensier; Queen of Navarre; Elizabeth of Austria, wife of Charles IX; Duke of Longueville. BOTTOM, LEFT TO RIGHT: Charles IX; councillor of the Parlement of Paris; Michel de l'Hospital, Chancellor of France; chancellor; gentleman of the reign of Charles IX (1560–1574).

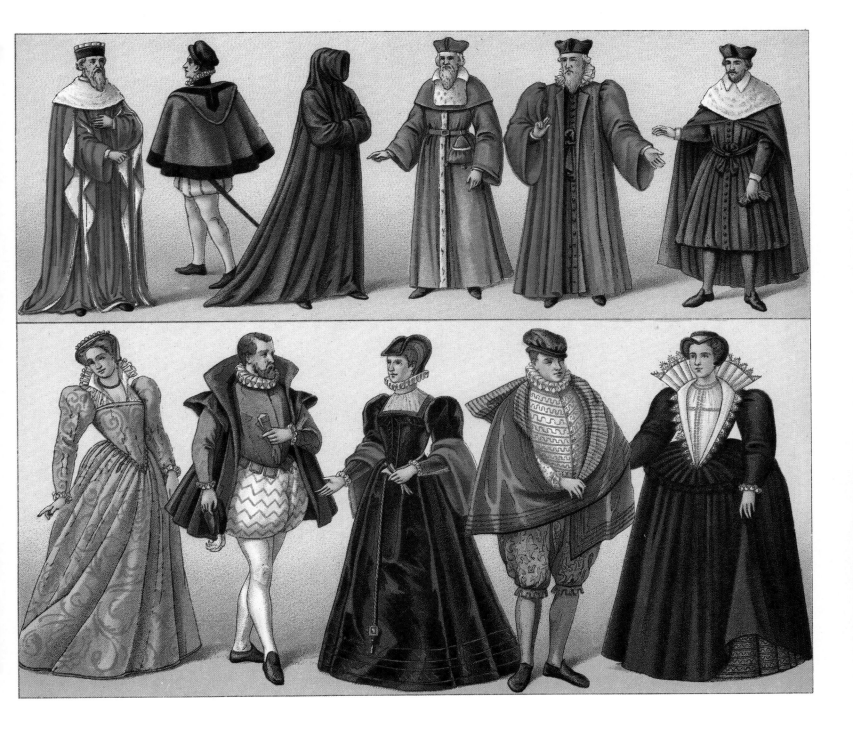

PLATE 45 · France, Fashions from 1560 to 1590, and Costumes of Civil Officials, 16th Century.

TOP, LEFT TO RIGHT: President of the Parlement of Paris; gentleman with cape, reign of Charles IX; mantle for deep mourning; rector of the University of Paris; provost of Parisian merchants; Dr. Jean Guillemer, 1586. BOTTOM, LEFT TO RIGHT: Lady, reign of Charles IX; townsman of the same period; lady of the same period; townsman; Anne de Thou, reign of Henri III.

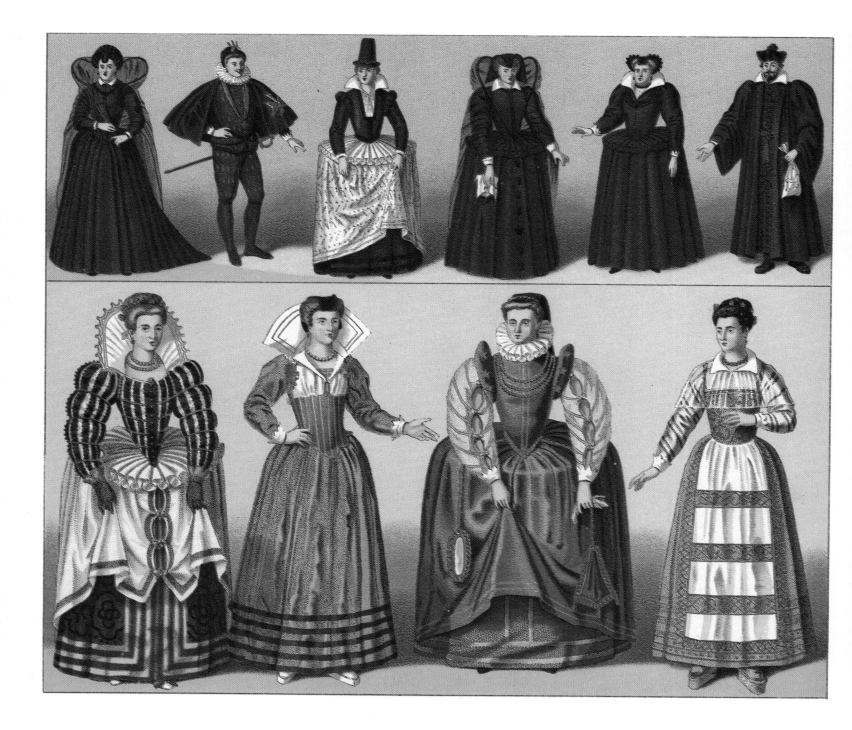

PLATE 46 · France, 16th Century.

TOP, LEFT TO RIGHT: Widow in mourning; Henri III; girl; girl or widow in mourning; townswoman in mourning; lawyer. BOTTOM, LEFT TO RIGHT: Lady; townswoman wearing a *corps de cotte*; townswoman; girl in a housecoat.

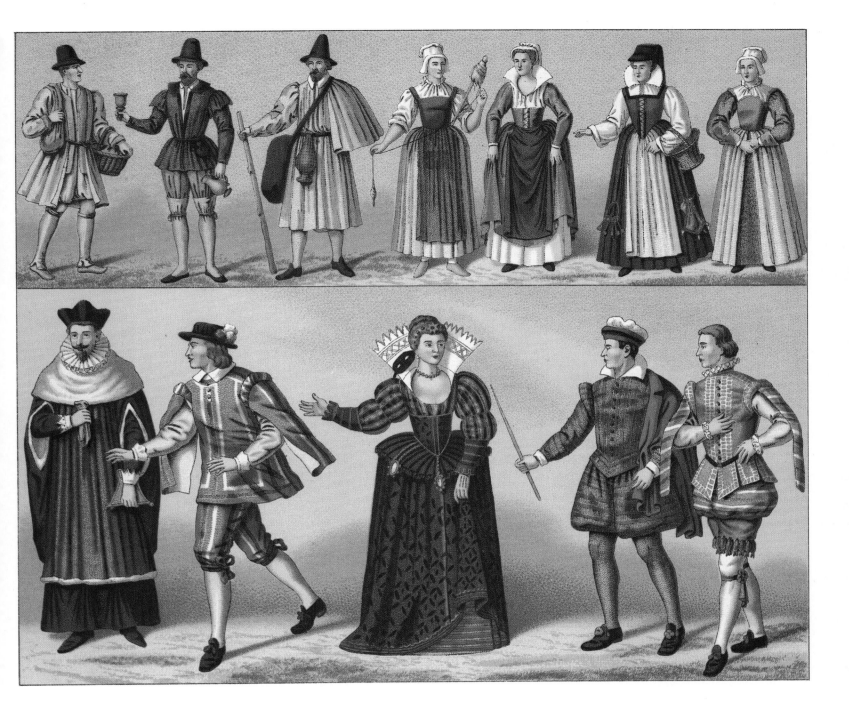

PLATE 47 · France, 1580s.

TOP, LEFT TO RIGHT: Peasant from Saumur; wine vendor; shoeblack vendor; shepherdess of Anjou; rich peasant woman; Parisian servant marketing; chambermaid from Saumur. BOTTOM, LEFT TO RIGHT: Doctor in ceremonial dress; valet in royal livery; young lady; lackey of a wealthy home; royal page.

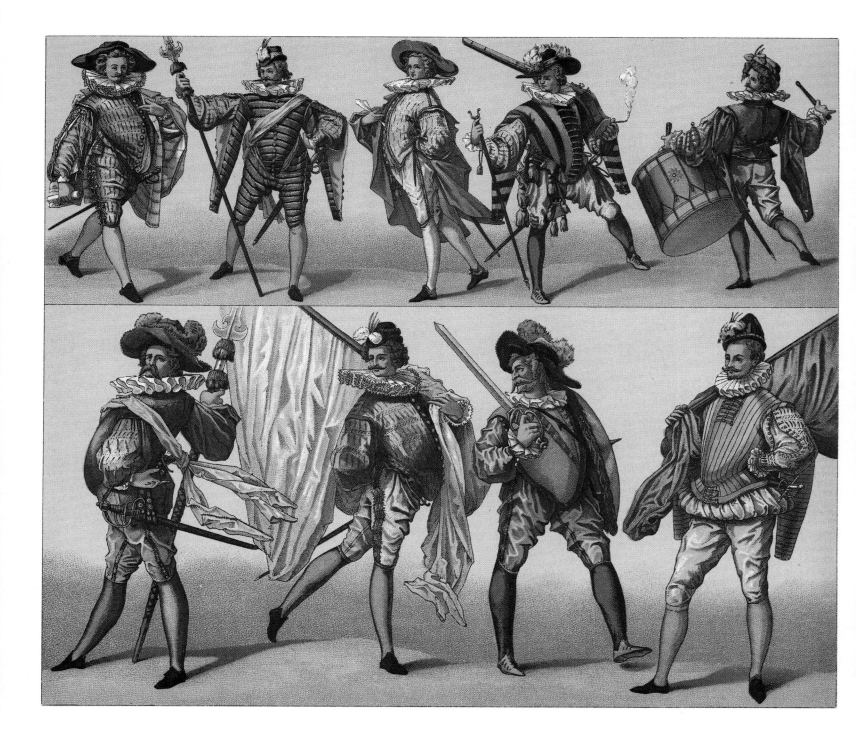

PLATE 48 · Infantry Dress in the Reign of Henri III (1574–1589).

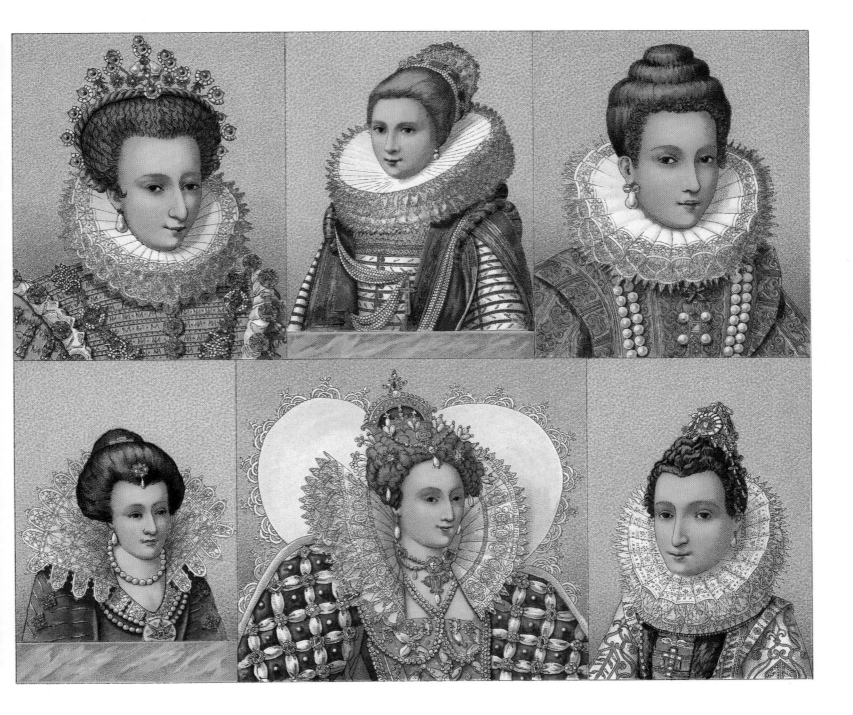

PLATE 49 · Women's Attire, 16th and 17th Centuries.

TOP, LEFT TO RIGHT: Catherine de Bourbon, 1600; Dutch lady, ca. 1600; Marie de Médicis, ca. 1600.
BOTTOM, LEFT TO RIGHT: Marie de Médicis; Elizabeth I of England; Isabelle, Archduchess of Austria, late 16th century.

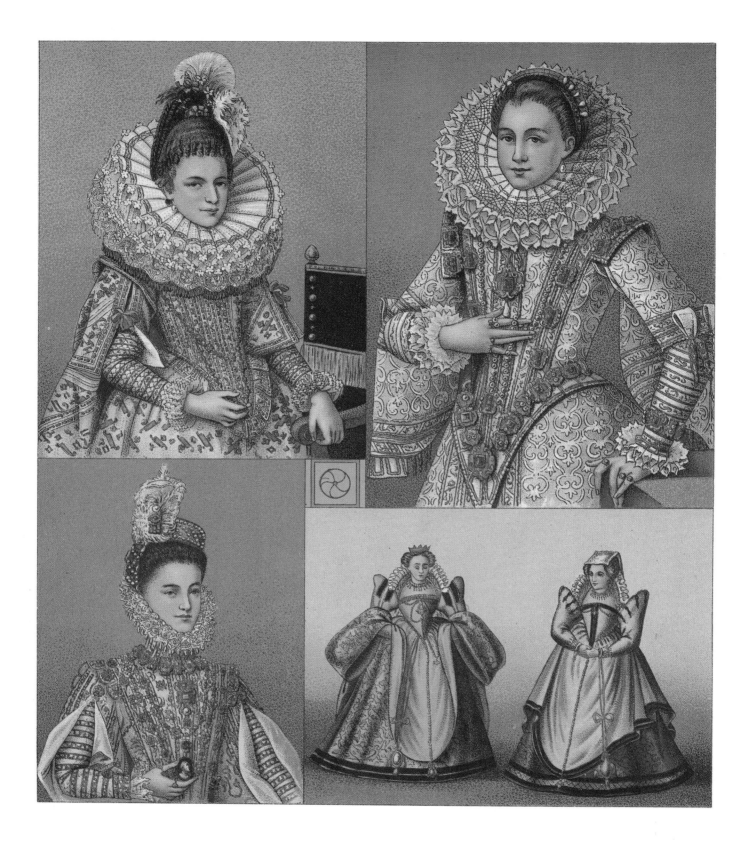

PLATE 50 · Women's Attire, 16th and 17th Centuries.

TOP: Unknown ladies. BOTTOM, LEFT TO RIGHT: Isabelle, Archduchess of Austria, late 16th century; two Parisian ladies, the one at the left in a wedding gown.

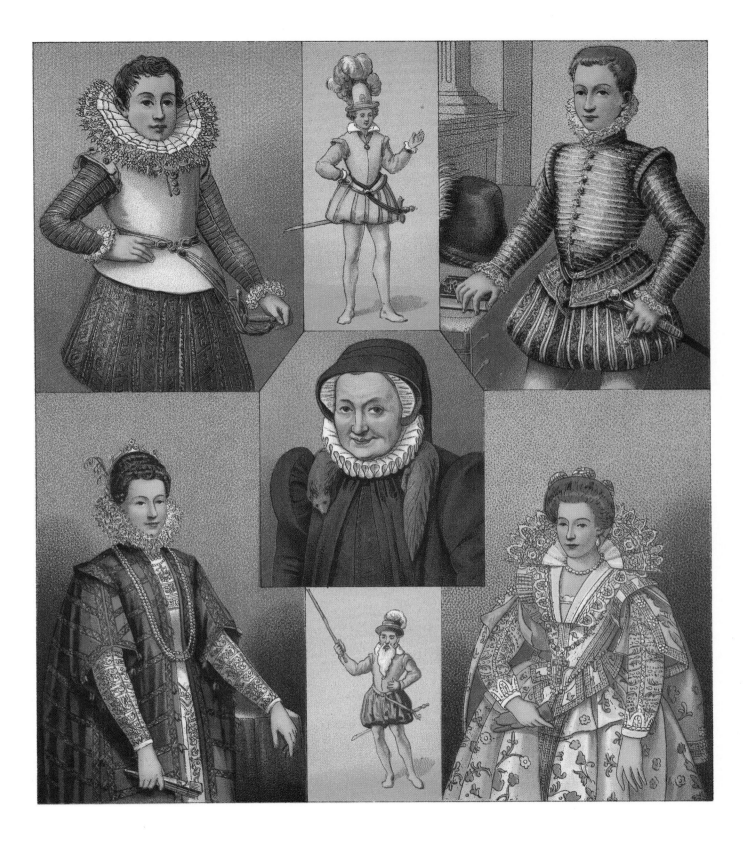

PLATE 51 · Fashions of the 16th Century.

TOP, LEFT TO RIGHT: The Duke of Alva as a boy; army officer; young French gentleman, ca. 1570.
CENTER: Dutch lady. BOTTOM, LEFT TO RIGHT: Princess Orsini; a sergeant major; German lady, 1555.

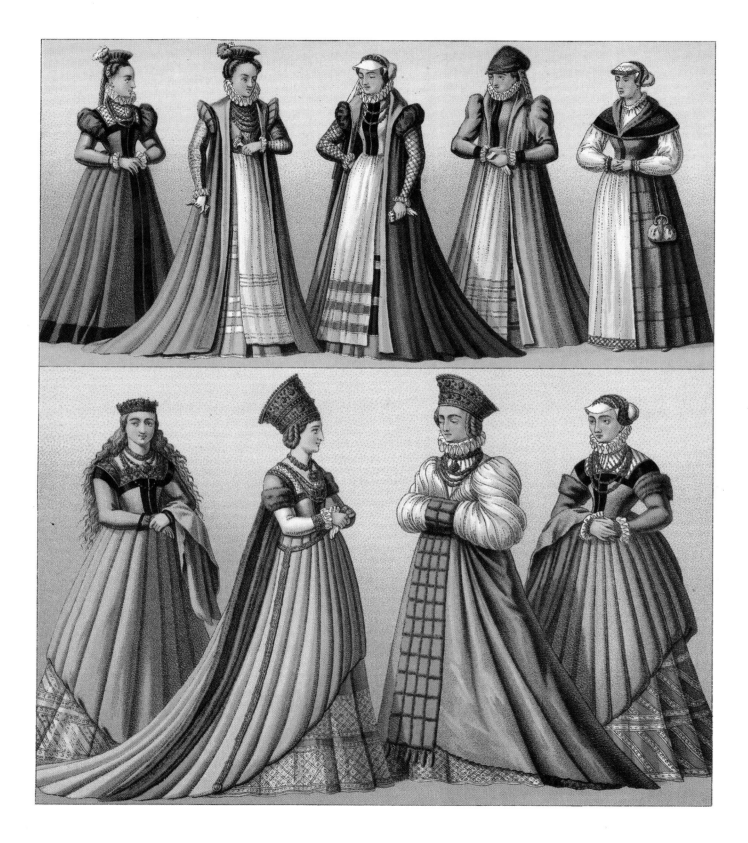

PLATE 52 · Women's Attire, Southwestern Germany, Late 16th and Early 17th Centuries.

TOP, LEFT TO RIGHT: Young noblewoman of Augsburg; Swabian noblewoman; noblewoman; mature townswoman; middle-class woman of Frankfurt. BOTTOM, LEFT TO RIGHT: Young noblewoman in festive attire; noblewoman dressed for festivities in Nuremberg; patrician woman in wedding dress; mature noblewoman dressed to attend a wedding.

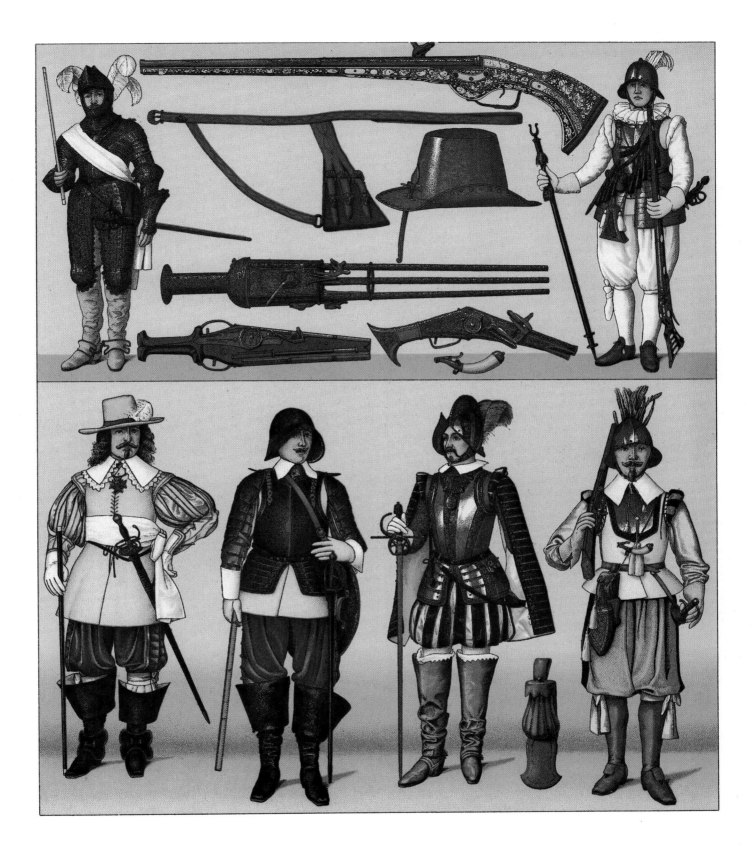

PLATE 53 · French Uniforms, Late 16th and Early 17th Centuries.

TOP: Infantry general (left); Protestant arquebusier (right); firearms, iron hat, powder horn and sword attachment of the era. BOTTOM, LEFT TO RIGHT: Cavalry general of the reign of Louis XIII; engineer officer of the same reign; officer, reign of Charles IX; musketeer's powder bag; musketeer, reign of Louis XIII.

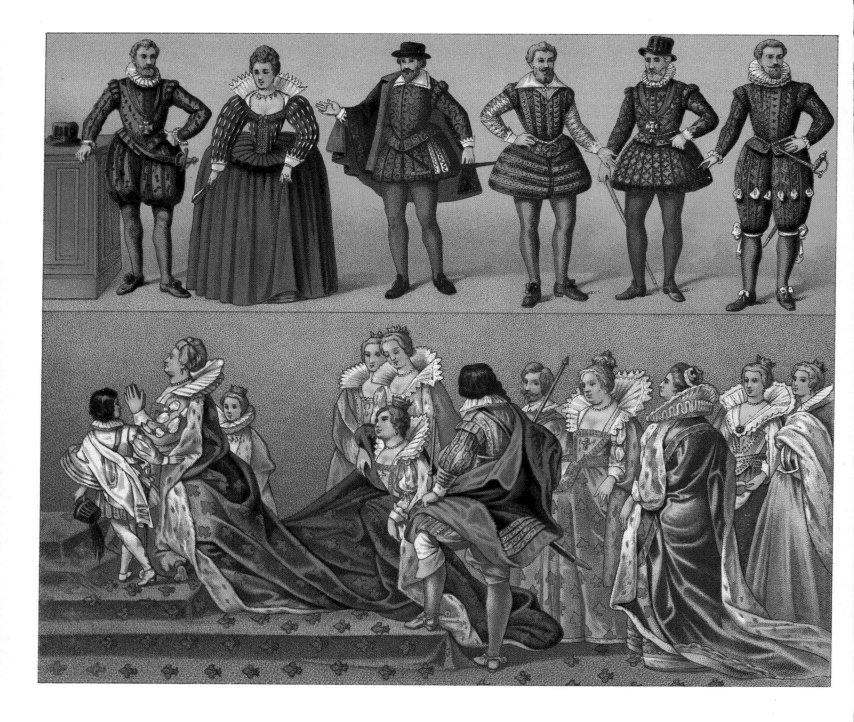

PLATE 54 · French Royalty and Nobility in the Reign of Henri IV (1589–1610).

TOP, LEFT TO RIGHT: Henri IV; Marguerite de France, his first wife; gentleman, 1605; Antoine de Saint-Chamand; Henri IV; Antoine de Saint-Chamand. BOTTOM: Coronation of Marie de Médicis.

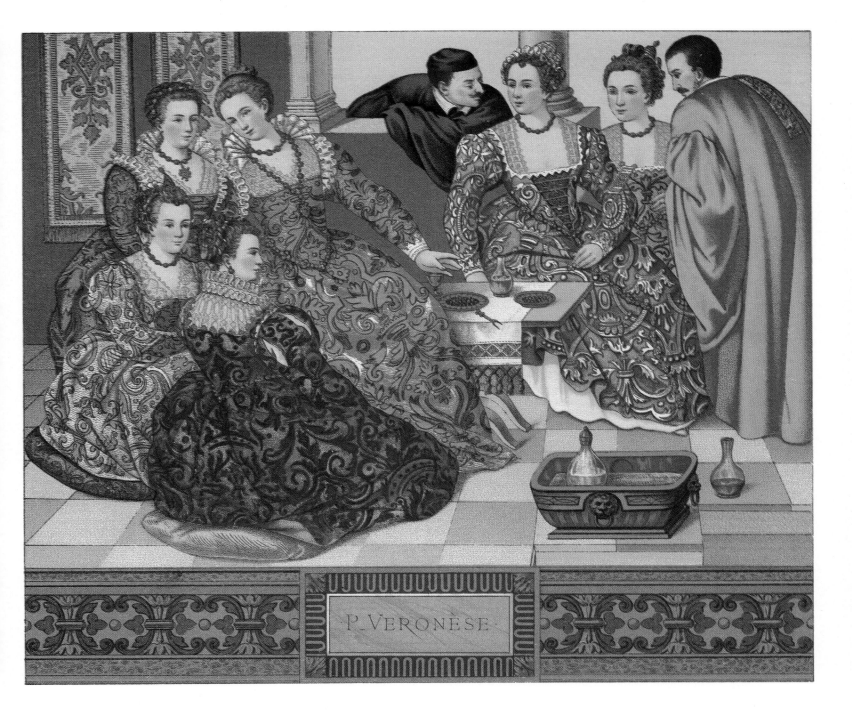

P. VERONESE

PLATE 55 · Venice, Second Half of 16th Century.

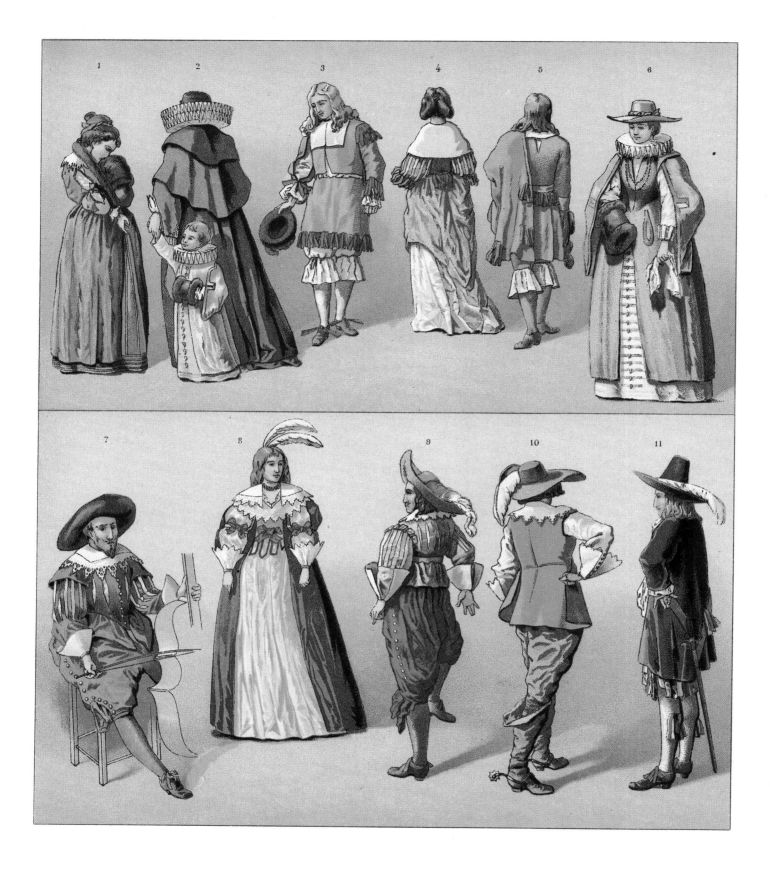

PLATE 56 · Holland, 17th Century.

1, 2, 6: Women in town clothes. 3, 5: Gallants. 4: Lady. 7: Wealthy townsman. 8: Lady in ball gown. 9: Dandy. 10: Cavalier. 11: Officer.

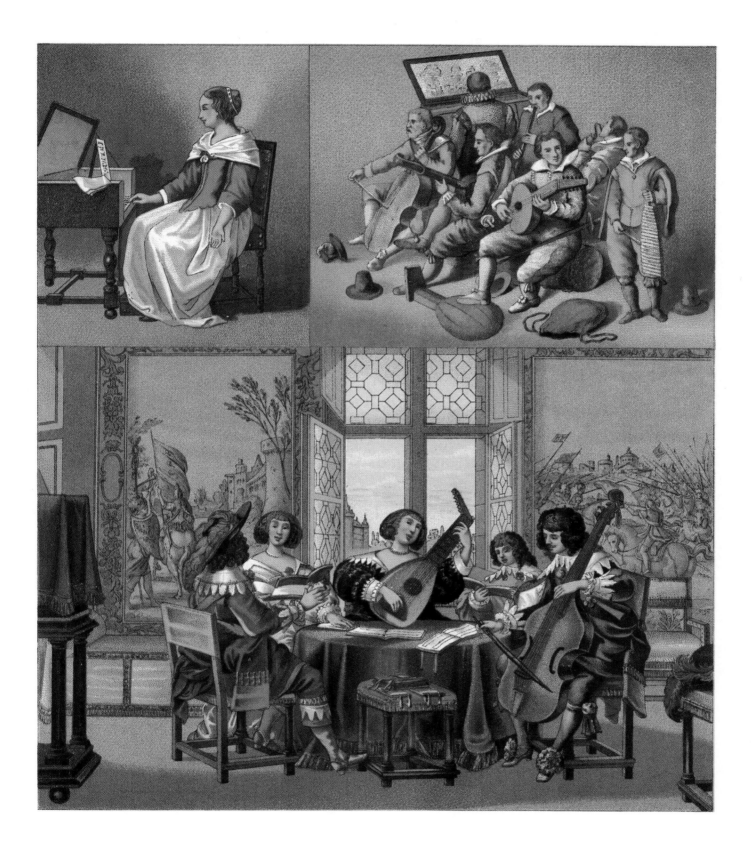

PLATE 57 · France and Flanders, 17th Century.

TOP, LEFT TO RIGHT: Young woman of Flanders; musicians at a Flemish truce celebration, 1609.
BOTTOM: French interior, ca. 1635.

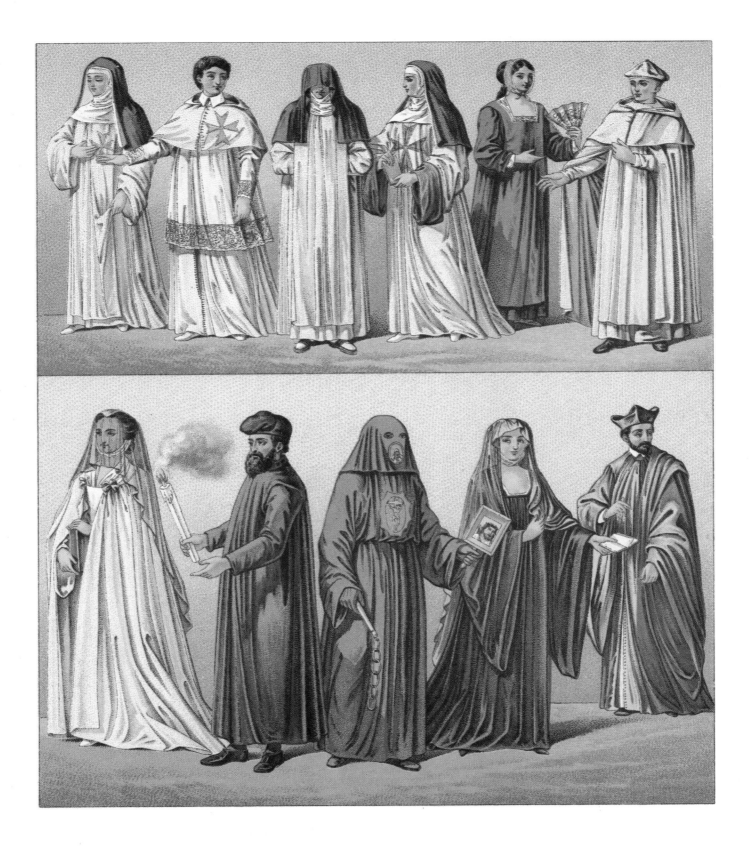

PLATE 58 · Religious Orders, Italy, 17th Century.

TOP, LEFT TO RIGHT: Nun, Order of St. Stephen of Florence, in standard attire; chaplain of the same order in ceremonial attire; nun of the Congregation of Corpus Christi; abbess of the Order of St. Stephen of Florence, in altar habit; noble Benedictine nun of the Convent of San Zaccaria, Venice, in standard attire. BOTTOM, LEFT TO RIGHT: Noble Augustinian nun, Venice; pallbearer, Venice; penitent, Venice; noble Benedictine of the Convent of San Zaccaria, Venice, in altar habit; secular canon of the Congregation of Saint George in Algha, Venice.

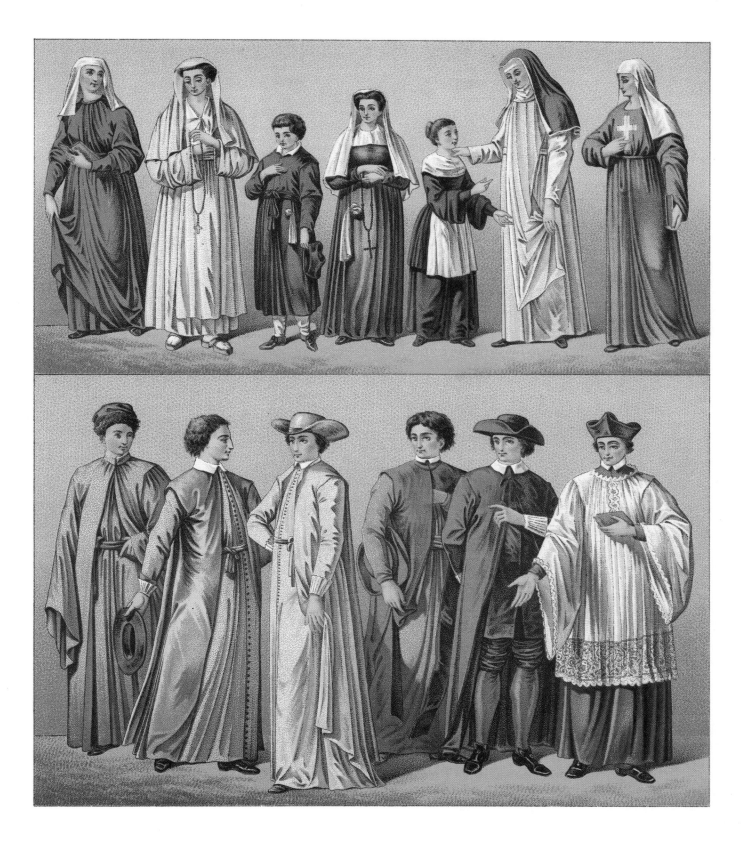

PLATE 59 · Religious Orders, Italy, 17th Century.

TOP, LEFT TO RIGHT: Ursuline of Sta. Rufina and Sta. Seconda, in standard attire; poor orphan known as a *zoccoletta*, in town clothes; foundlings; orphan attached to the Convent of St. Catherine; nun of the same convent; a sister of mercy. BOTTOM: Students of Roman religious colleges (LEFT TO RIGHT): College of the Greeks; College of the Nazarenes; Salviati College; College of the Scots; Mattei College; College of the Germans and Hungarians (in altar habit).

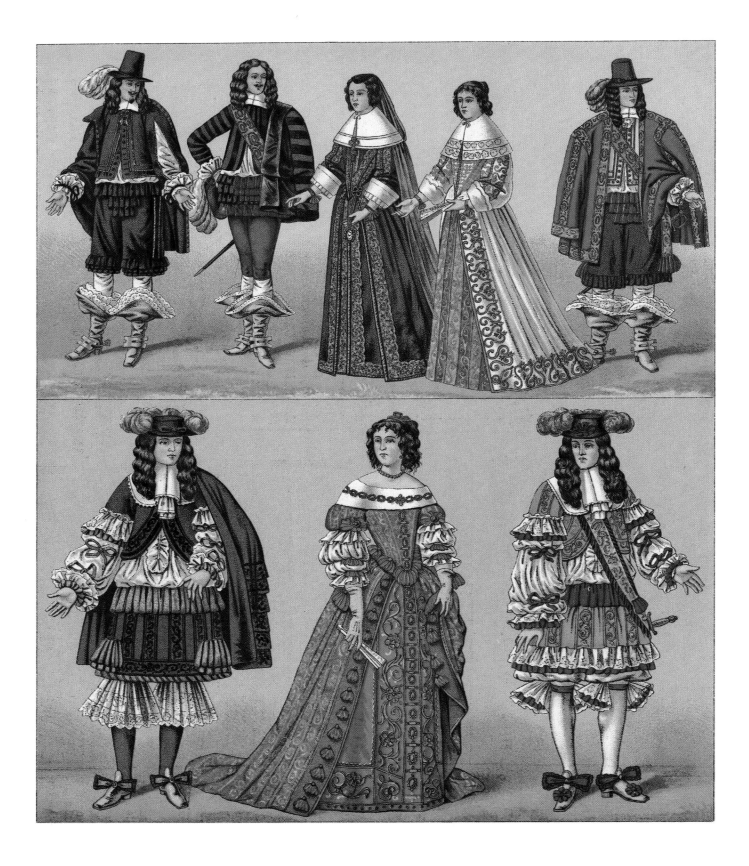

PLATE 60 · French Royalty and Nobility, 1646–1670.

TOP, LEFT TO RIGHT: Gentleman of the entourage of the Maréchale de Guébriant, ambassadress to Poland in the 1640s; one of her pages; the Maréchale; one of her attendant ladies; another of her gentlemen. BOTTOM, LEFT TO RIGHT: Louis XIV, 1660; Marie-Thérèse of Austria, his wife, 1660; Louis XIV, 1670.

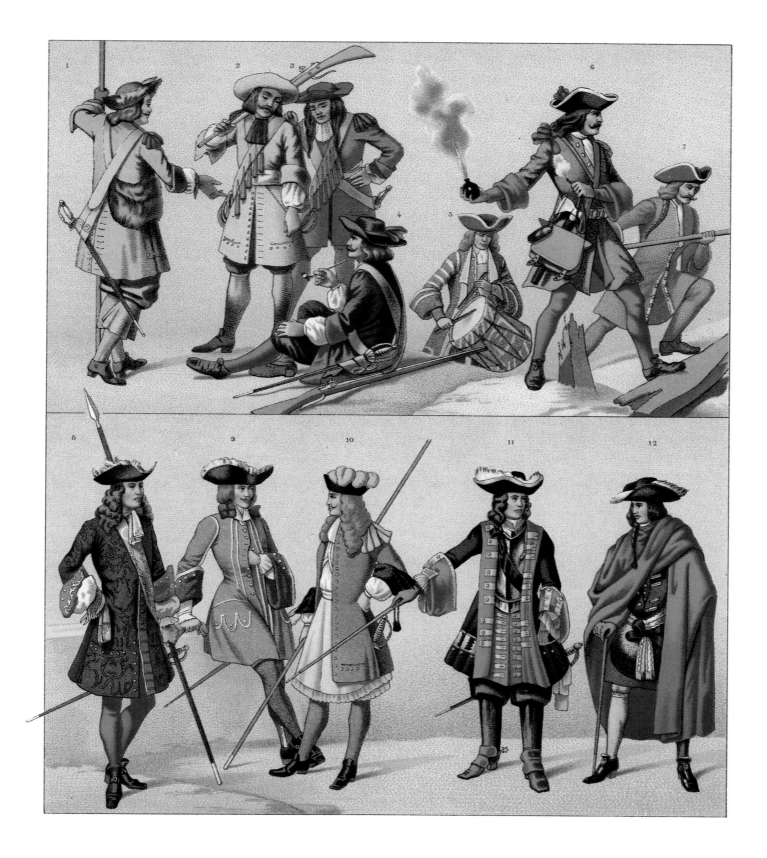

PLATE 61 · French Infantry, 1660–1696.

1: Pikeman, 1667. **2–4**: Musketeers, 1667. **5**: Drummer in the Marquis de Jovyac's regiment, 1696. **6**: Grenadier in the same regiment. **7**: Sergeant in the regiment of Provence, 1696. **8**: Officer of the French Guards, 1685. **9**: Militia officer, 1688. **10**: Officer, 1660. **11**: General, 1694. **12**: Officer in winter uniform, 1685.

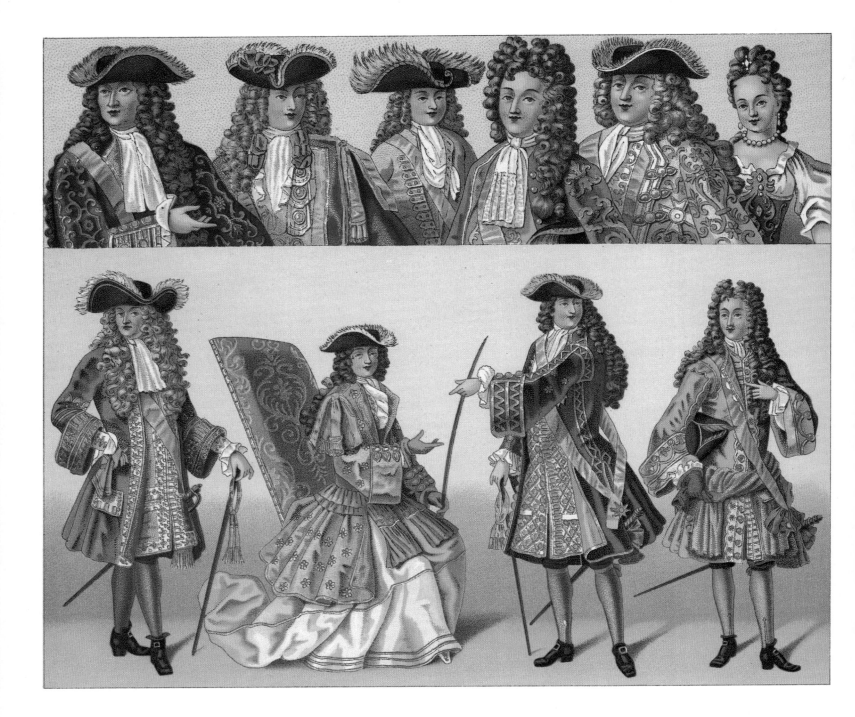

PLATE 62 · French Royalty, 17th Century.

TOP, LEFT TO RIGHT: Louis XIV; the Count of Toulouse; unidentified; Louis, the dauphin; unidentified; the Princess of Savoie. BOTTOM, LEFT TO RIGHT: Louis XIV; Charlotte Palatine, second wife of the Duke of Orleans; Louis, the dauphin; the Duke of Orleans.

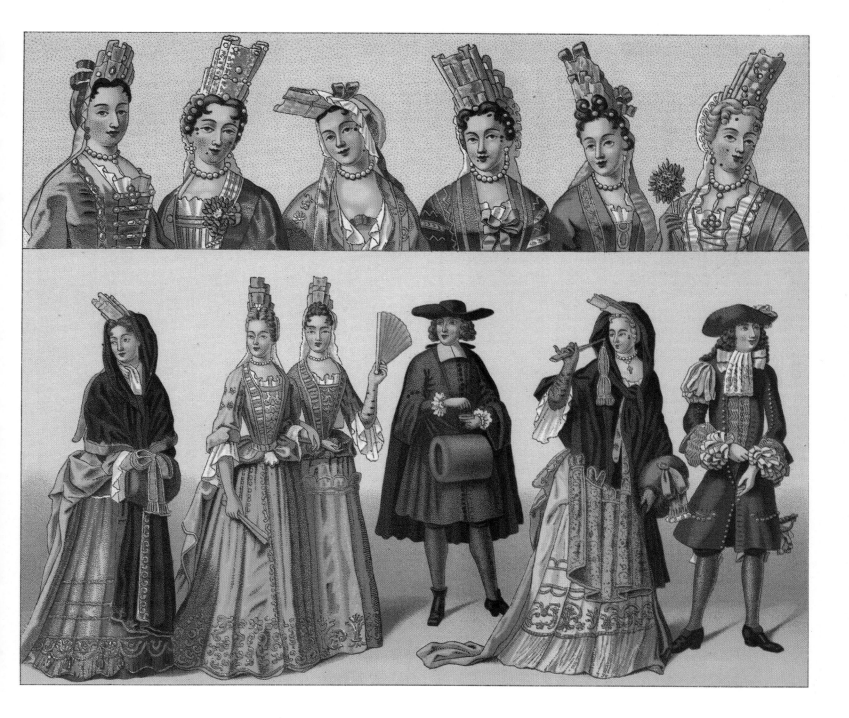

PLATE 63 · French Nobility, 17th Century.

TOP, LEFT TO RIGHT (all with *fontange* headdresses): Mme. de Maintenon; the Princess de Conti; the Duchess of Bourbon; Elisabeth-Charlotte de Bourbon; the Countess of Egmont; the Duchess of Chartres. BOTTOM, LEFT TO RIGHT: Noblewoman in winter wear; the two Mlles. Loison; an abbé; noblewoman with scarf; gentleman in summer wear.

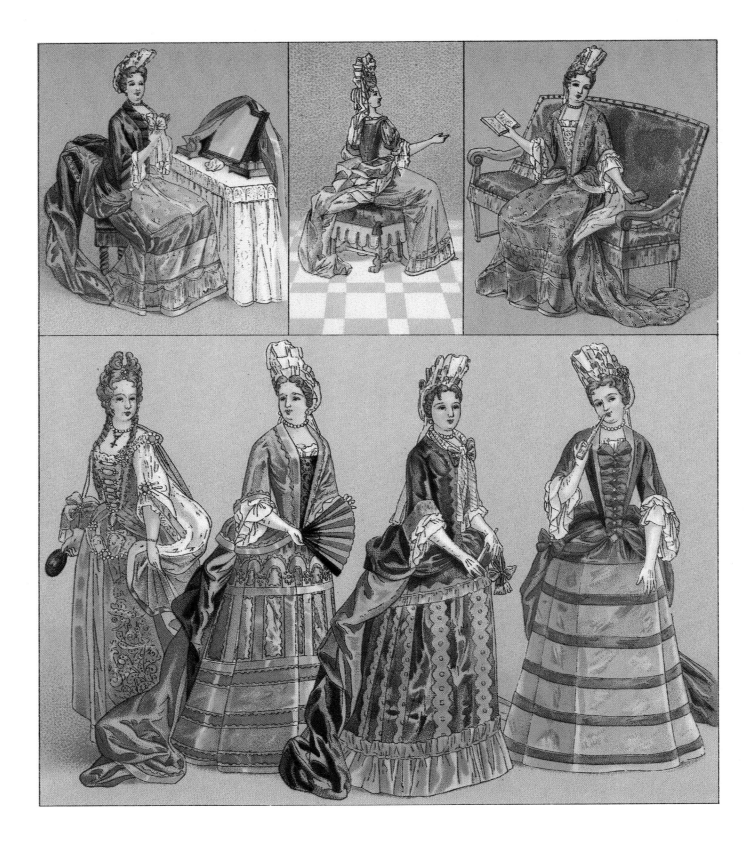

PLATE 64 · Women's Attire, France, 17th Century.

TOP ROW AND FARTHEST LEFT FIGURE IN BOTTOM ROW: Four examples of sumptuous ball gowns.
REMAINDER OF BOTTOM ROW: Elaborate costumes featuring the *fontange* headdress.

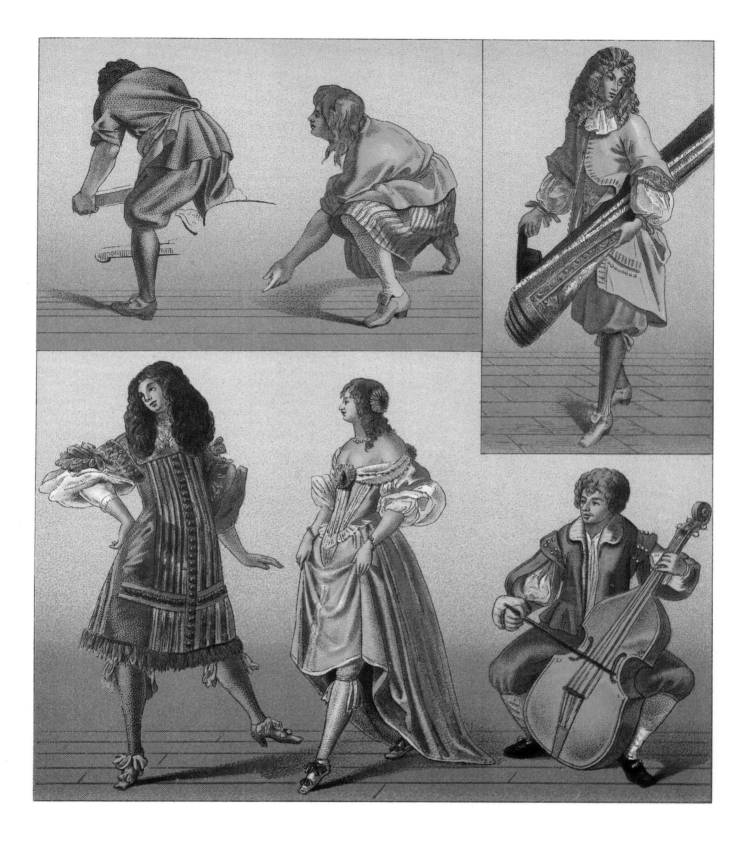

PLATE 65 · France, 1667–1680.

TOP: Figures of two workmen and a supervisor from a tapestry depicting the royal furniture and carpet factory in 1667. BOTTOM (ca. 1680): Man and woman dressed for a ball; musician of the ball orchestra.

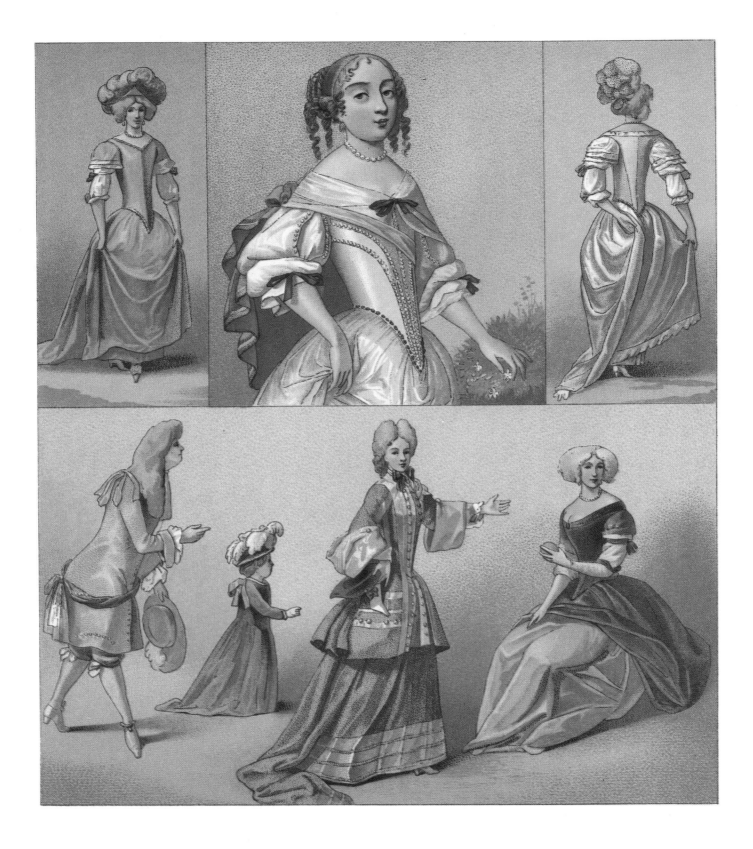

PLATE 66 · France, Late 17th or Early 18th Century.

TOP, LEFT TO RIGHT: Ball costume; lady; ball costume. BOTTOM, LEFT TO RIGHT: Two ball costumes; Louise-Adélaïde de Bourbon-Conti in riding dress; ball costume.

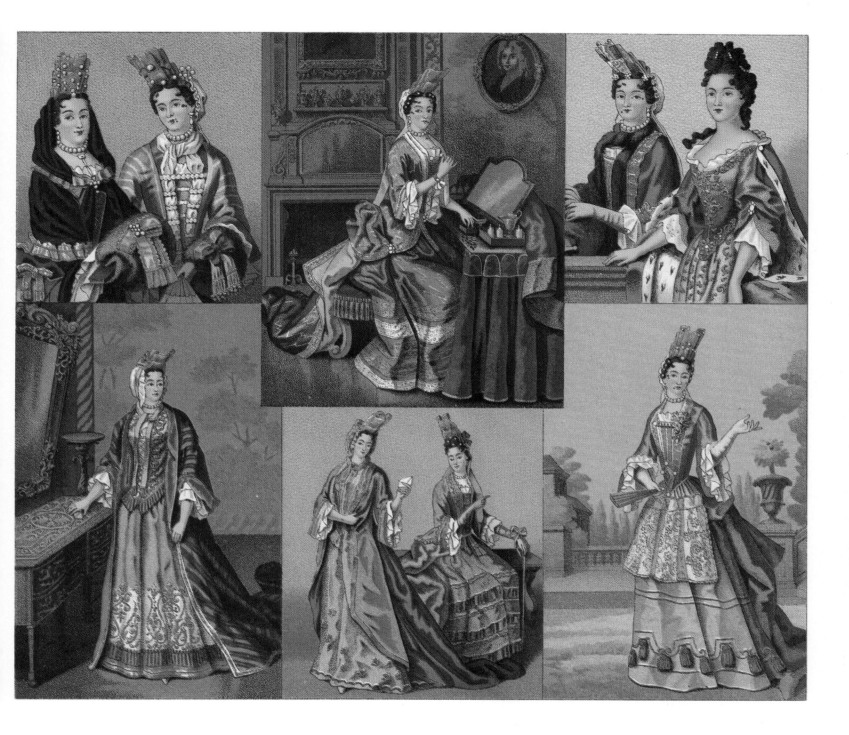

PLATE 67 · Noblewomen's Dress, France, Later 17th Century.

TOP, LEFT TO RIGHT: Mme. de Maintenon in town clothes; the Princess de Conti; the Countess de Mailly; the Princess de Conti in winter dress; Mlle. de Chartres in ceremonial attire. BOTTOM, LEFT TO RIGHT: the Countess de Montfort in a winter dressing gown; the Marquise de Richelieu in a summer dressing gown; the Countess of Egmont in promenade costume; the Duchess of Aiguillon with a lace apron.

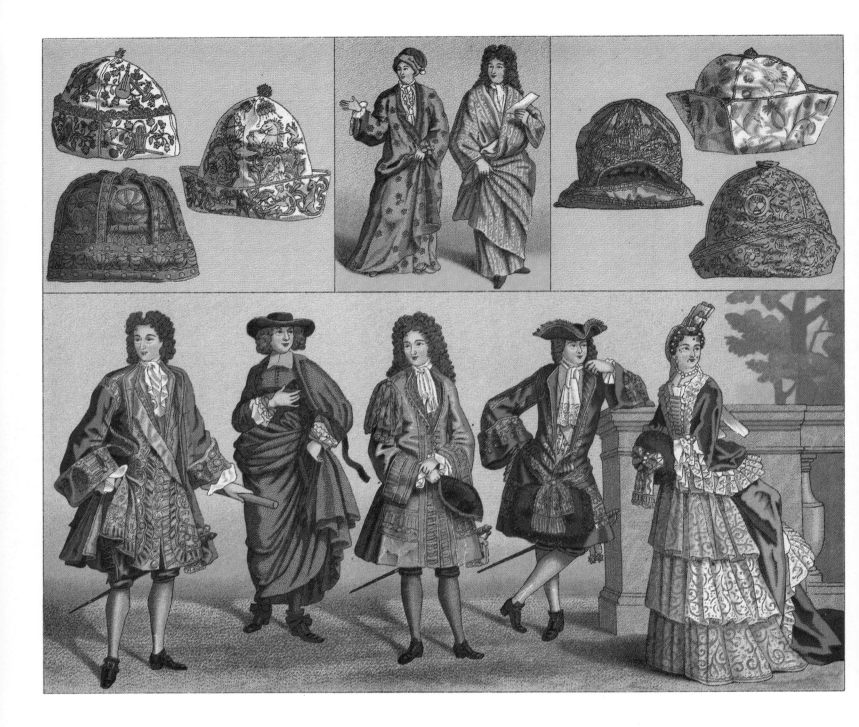

PLATE 68 · Clothing of Royalty and Nobility, Chiefly France, Late 17th and Early 18th Centuries.

TOP: Six men's indoor caps, 17th and 18th centuries; gentlemen in dressing gowns. BOTTOM, LEFT TO RIGHT: The Prince de Conti, 1697; an abbé; the Duke de Lesdiguières, 1696; the Duke du Maine; Charlotte, queen of Denmark.

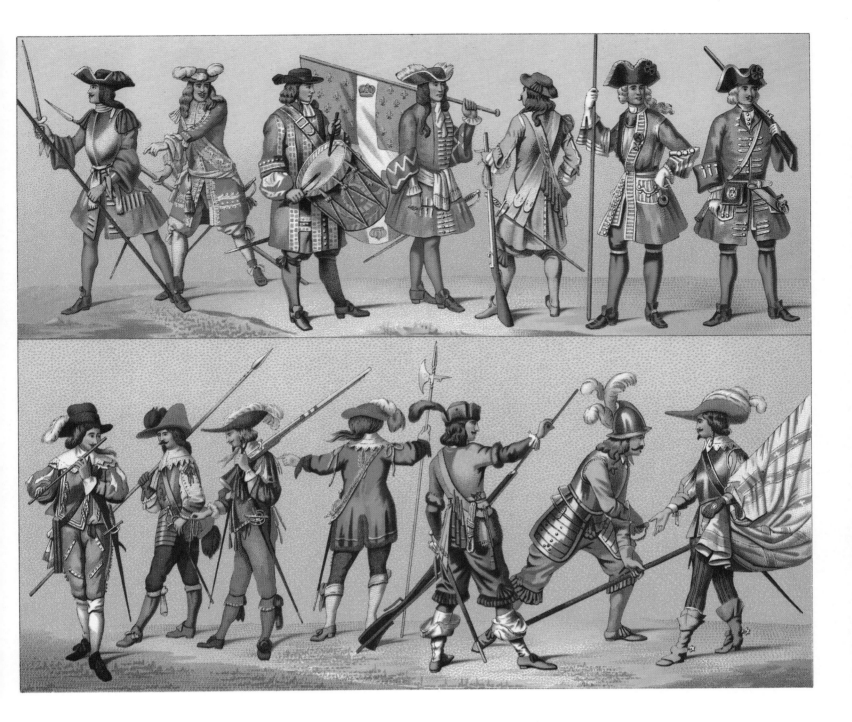

PLATE 69 · French Military Uniforms, 17th and 18th Centuries.

TOP, LEFT TO RIGHT: Pikeman, 1697; officer, 1664; drummer, 1664; standard-bearer, 1697; musketeer, 1664; officer, 1724; soldier, 1724. BOTTOM, LEFT TO RIGHT: Fifer, 1630; pikeman, 1630; musketeer, 1630; sergeant, 1630; musketeer, 1647; pikeman, 1647; standard-bearer, 1630.

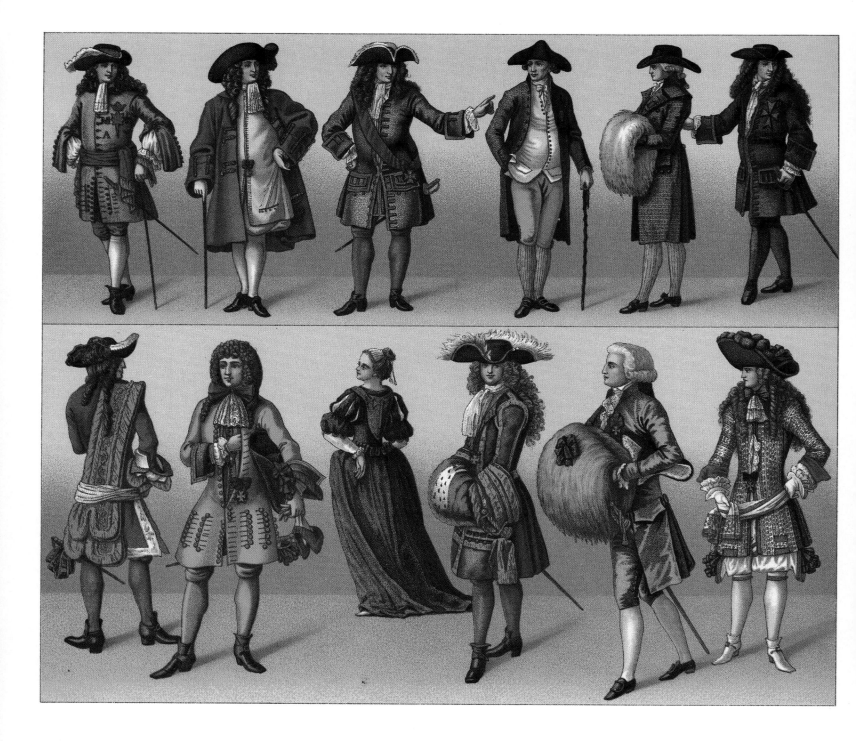

PLATE 70 · French Civilians Decorated with Chivalric Orders, 17th and 18th Centuries.

TOP, LEFT TO RIGHT: Knight of the Star, second half of the 17th century; knight of Saint Louis, early 18th century; unidentified; knight of the Two Swords, reign of Louis XVI; knight of Saint Louis, Paris, 1784; knight of the Hospital of Aubrac, early 18th century. BOTTOM, LEFT TO RIGHT: Knight of Saint Louis, 1693; knight of Malta, 1678; dame of the Order of the Ax, early 17th century; Commander of Saint Louis, 1693; knight of Saint Louis, 1787; knight of Malta, page of Louis XIV, 1678.

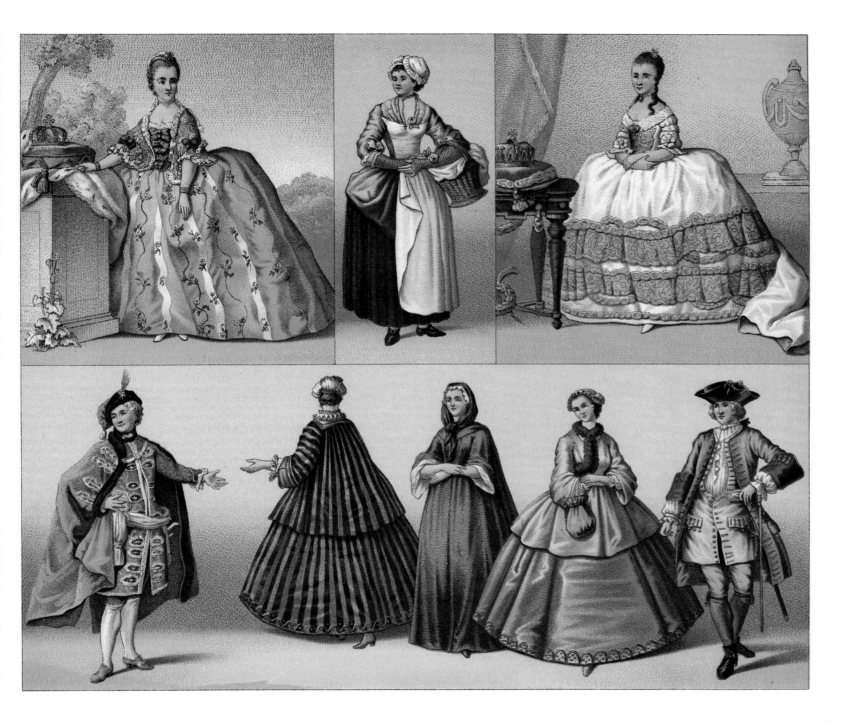

PLATE 71 · Europe, 18th Century.

TOP, LEFT TO RIGHT: Maria Louisa, wife of Holy Roman Emperor Leopold II; French peasant woman; the Duchess of Massa. BOTTOM, LEFT TO RIGHT: Ulrica Eleanor, queen of Sweden, in Polish-style masculine garb; French lady wearing a *casaquin*; French townswoman, 1741; lady in a *casaquin*; gentleman, 1730.

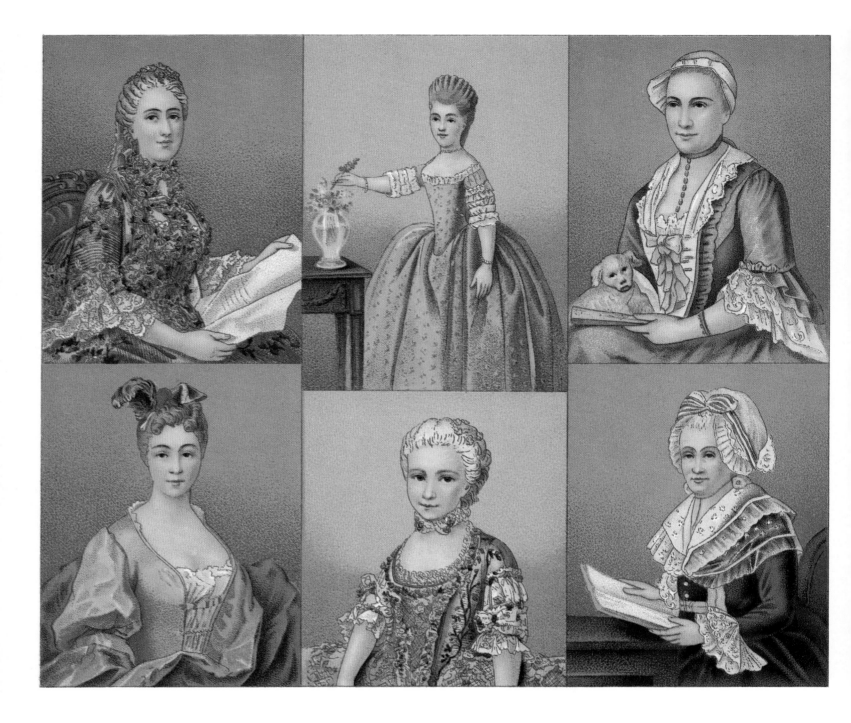

PLATE 72 · Women's Attire, France, 18th Century.

TOP, LEFT TO RIGHT: Lady, 1760; girl wearing a *fourreau*; townswoman. BOTTOM, LEFT TO RIGHT: Lady, ca. 1720; girl, ca. 1745; lady, 1789.

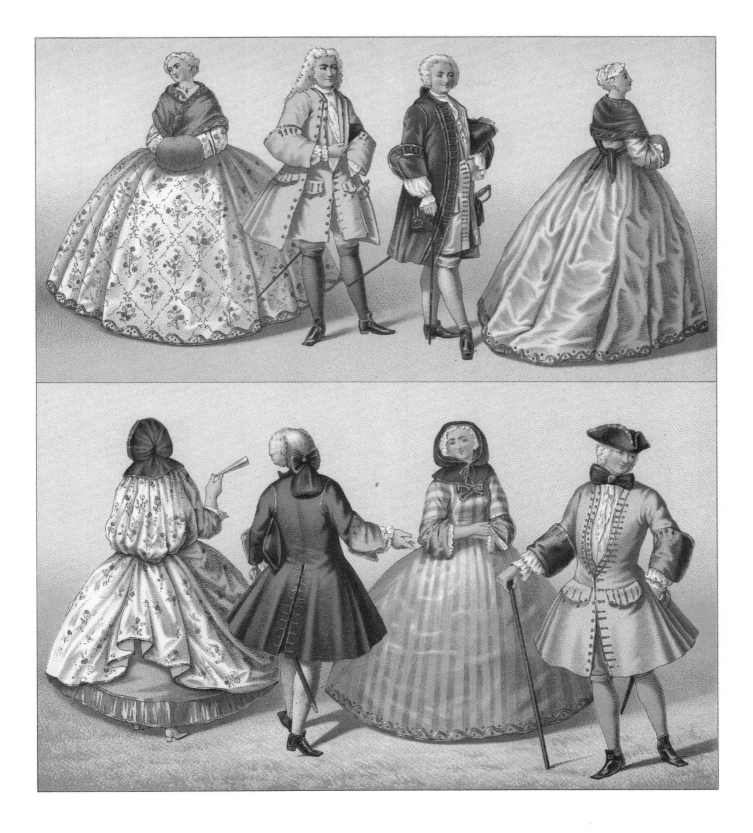

PLATE 73 · French Fashions, First Half of 18th Century.

TOP, LEFT TO RIGHT: Lady with *mantille* (wraparound scarf); man with "pagoda" sleeves; man in ordinary attire; lady with *mantille*. BOTTOM: Two ladies with *bagnolettes* (winter hoods touching the shoulders); two men in ordinary attire.

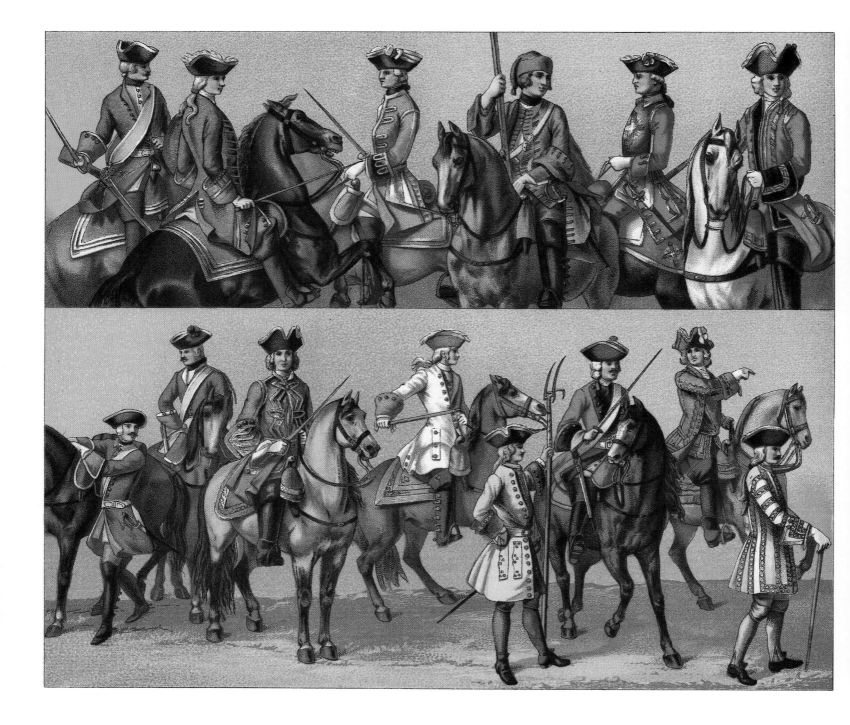

PLATE 74 · French Military Uniforms, 1724–1745.

TOP, LEFT TO RIGHT: Royal regiment of carabineers, 1724; carabineer colonel, 1724; light cavalryman of the king's guard, 1745; dragoon, 1724; king's guard musketeer, 1745; officer of the guard gendarmerie, 1724. BOTTOM, LEFT TO RIGHT: Guardsman of the company of the provost of mounted constabulary of Ile-de-France, 1724; guardsman of the mounted constabulary; provost, guard of the high constable's office, 1724; infantry field officer, 1724; grenadier sergeant, dauphin's regiment, 1724; sergeant of the Colonel-Général regiment, 1724; marshal, 1724; drum major of Linck's regiment, foreign infantry corps, 1724.

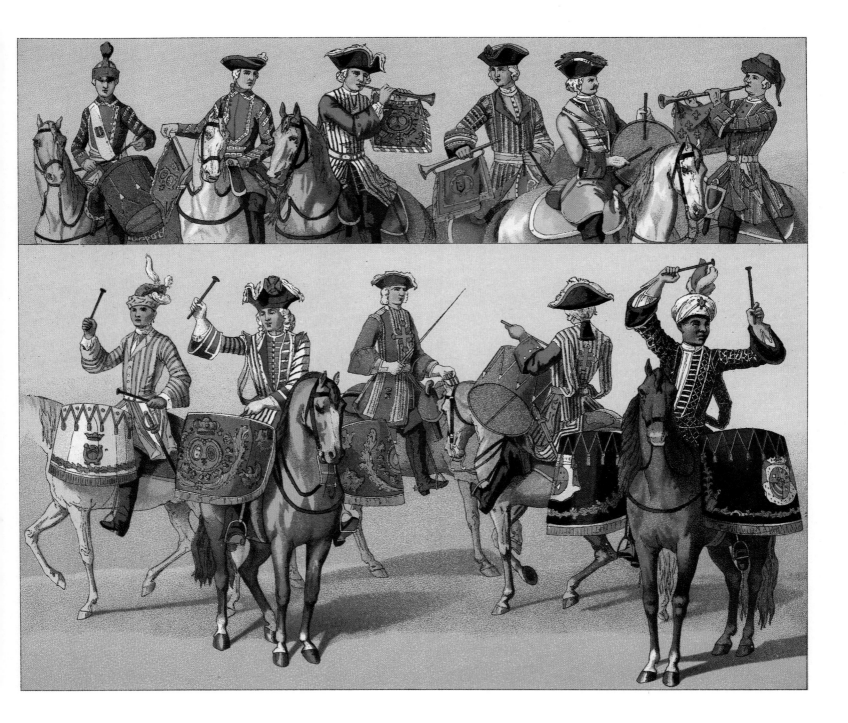

PLATE 75 · French Cavalry Band Uniforms, 18th Century.

TOP, LEFT TO RIGHT: Mounted drummer of the dauphin's dragoons, before 1776; trumpeter of the Royal-Pologne regiment in the king's livery, after 1772; oboist of the king's guard musketeers, 1724; trumpeter of the gendarmerie of France; drummer and oboist from dragoon regiments. BOTTOM, LEFT TO RIGHT: Timpanist from the Villeroy regiment; timpanist of the king's lifeguards; drummer and corporal of the king's guard musketeers, 1724; timpanist of the Colonel-Général regiment.

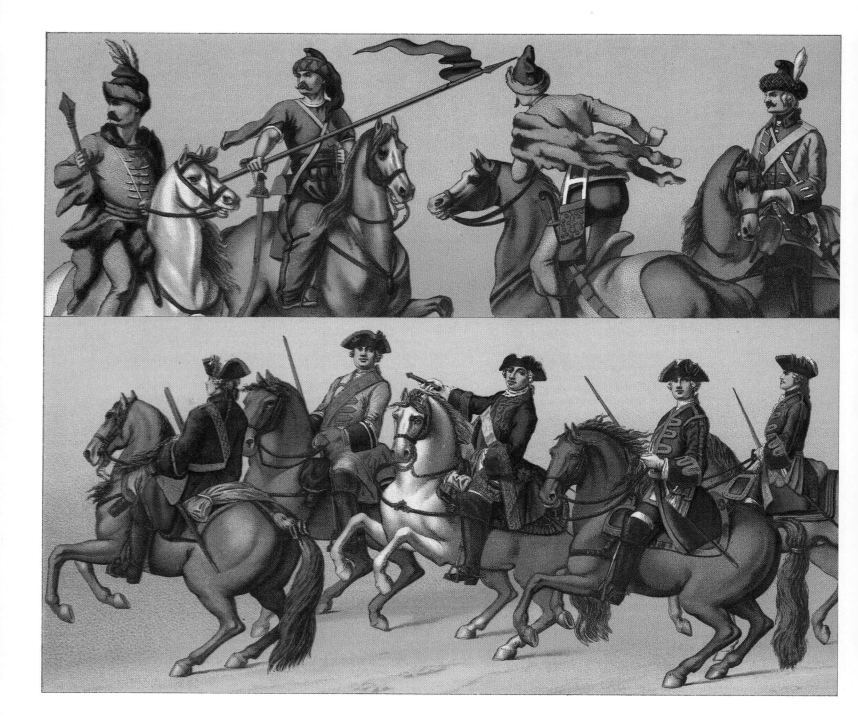

PLATE 76 · French Military Uniforms, First Half of 18th Century.

TOP, LEFT TO RIGHT: Officer of Rattky's hussars, 1724; one of Berchény's hussars, 1724; uhlan of Marshal de Saxe's volunteers, 1745; foreign volunteers of Clermont-Prince, 1745. BOTTOM, LEFT TO RIGHT (all 1757): *Gendarme*; king's guardsman, Scottish company; Louis XV; *gendarme* of the guard; light cavalryman of the lifeguard.

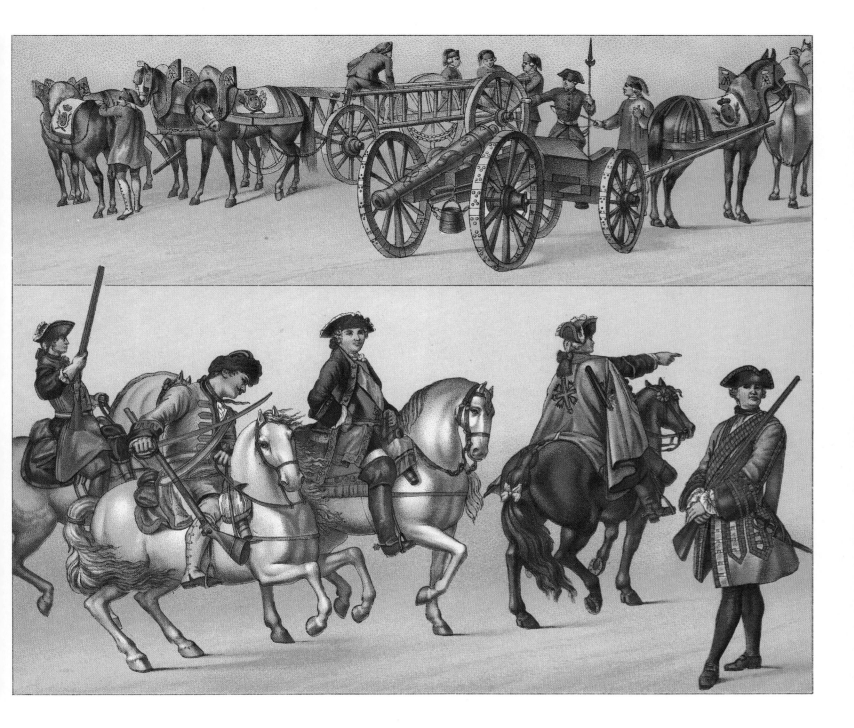

PLATE 77 · French Military Uniforms, 18th Century.

TOP: Field artillery, 1745. BOTTOM, LEFT TO RIGHT (all attached to the king's military household): "Gray" musketeer; mounted grenadier; the Dauphin (father of Louis XVI); "black" musketeer; palace gate guard.

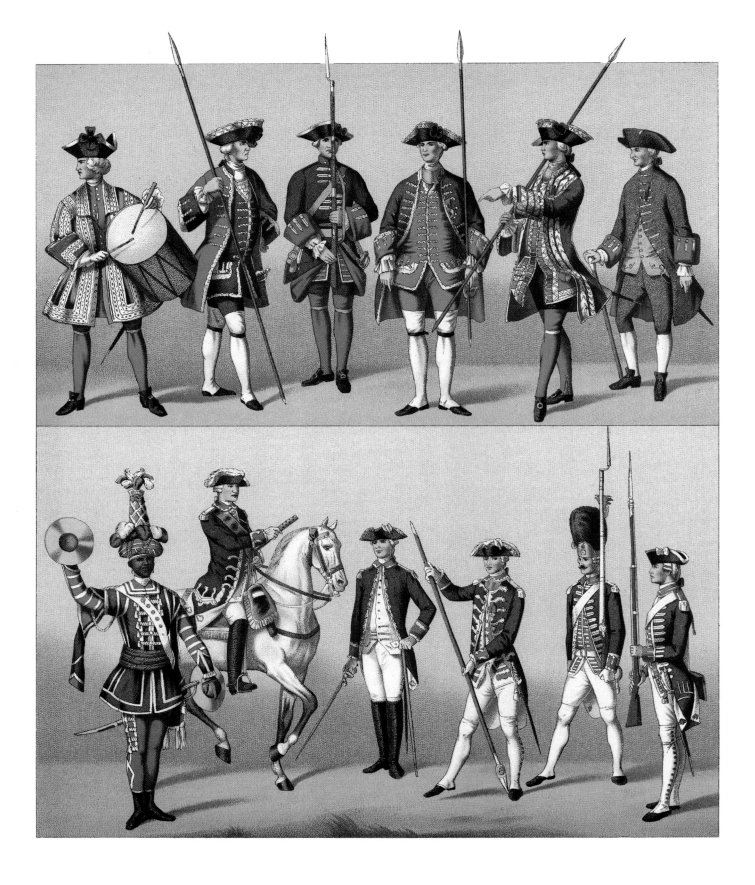

PLATE 78 · French Guards and Swiss Guards of the French Army, 18th Century.

TOP, LEFT TO RIGHT: Drummer, French Guards, 1724; officer, Swiss Guards, undress, 1757; soldier, French Guards, full dress, 1757; officer, French Guards, undress, 1757; same officer, full dress; invalid officer. BOTTOM, LEFT TO RIGHT: Regimental cymbalist, French Guards, 1786; colonel, French Guards (and marshal), 1786; staff officer in simplest uniform, French Guards, 1786; officer; grenadier; corporal of fusileers (the last three all in full dress, 1786).

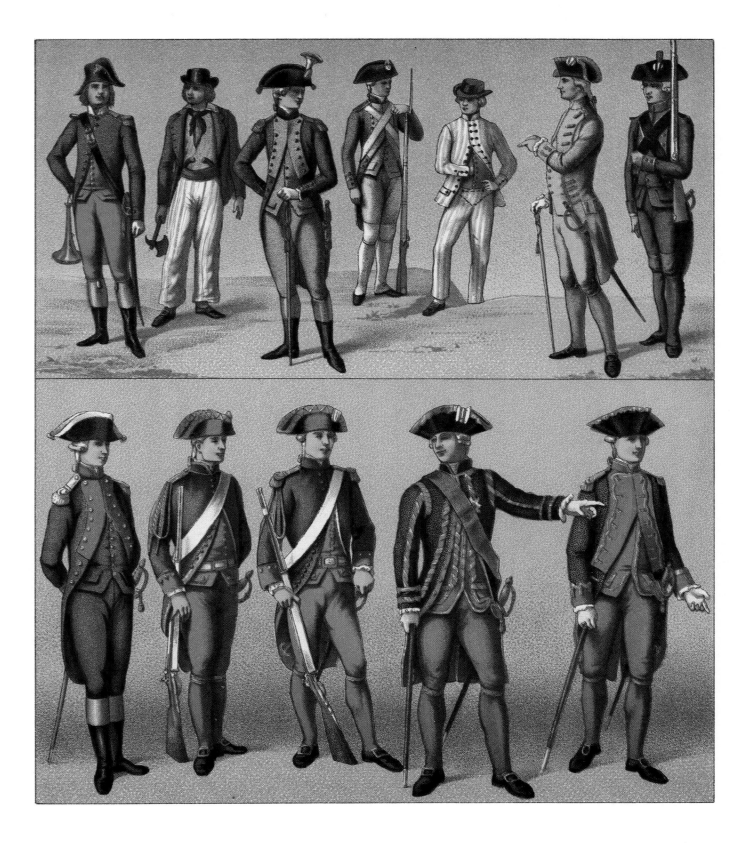

PLATE 79 · French Naval Uniforms, 18th Century.

(The first two figures are of the republican navy, 1792; all the rest, of the royal navy, 1786.) TOP, LEFT TO RIGHT: Officer; sailor; coast guard officer; coast guardsman; sailor; surgeon; marine, Brest regiment. BOTTOM, LEFT TO RIGHT: Marine officer, Brest regiment; guard of the admiral's flag; navy guard; admiral; vice-admiral.

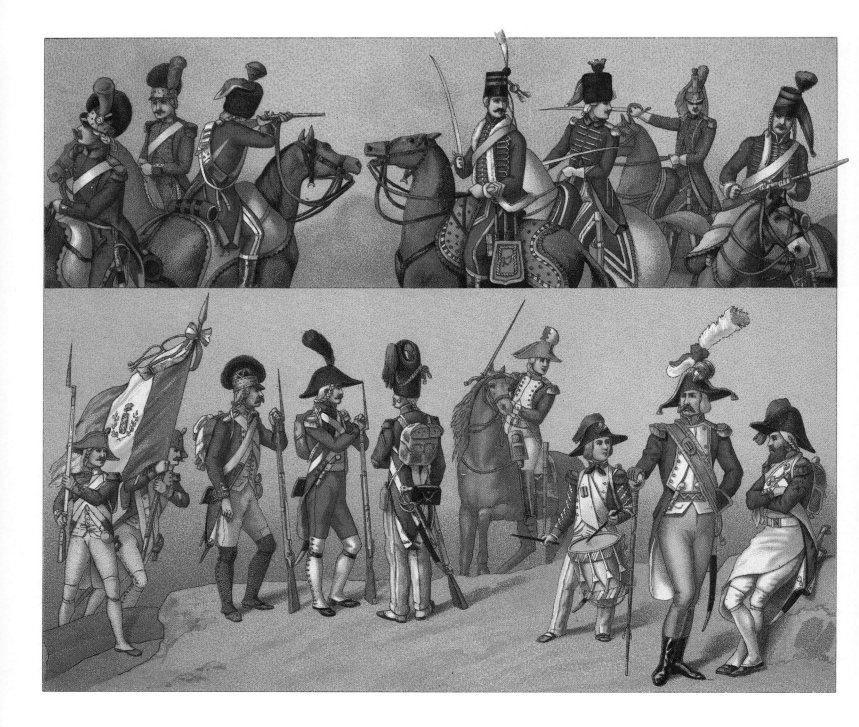

PLATE 80 · Republican French Regular Troops, 1792 and 1793.

TOP, LEFT TO RIGHT: Two light artillerymen; Hussar of Liberty; officer of the 7th Hussars; officer of Hussars of Liberty; officer of light artillery; soldier of the 7th Hussars. BOTTOM, FOURTH FROM LEFT: Members of special engineer battalion. OTHERS IN BOTTOM ROW (all in infantry of the line, not named in order): Commander, drum major, drummer, engineer, fusileers.

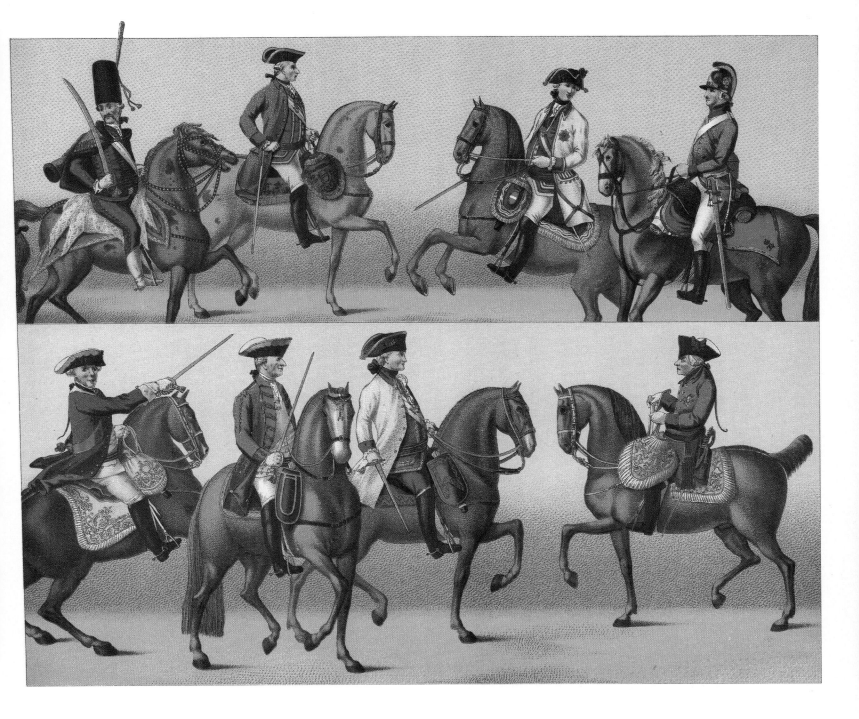

PLATE 81 · German Military Uniforms of the Seven Years' War.

TOP, LEFT TO RIGHT: Count Nadasky, an Austrian hussar general; Holy Roman Emperor Joseph II; Archduke Maximilian of Austria; Austrian dragoon. BOTTOM, LEFT TO RIGHT: Prince Henry of Prussia, brother of Frederick the Great; the Prussian infantry general Ramin; Count Lascy, an Austrian general; Frederick II (the Great) of Prussia.

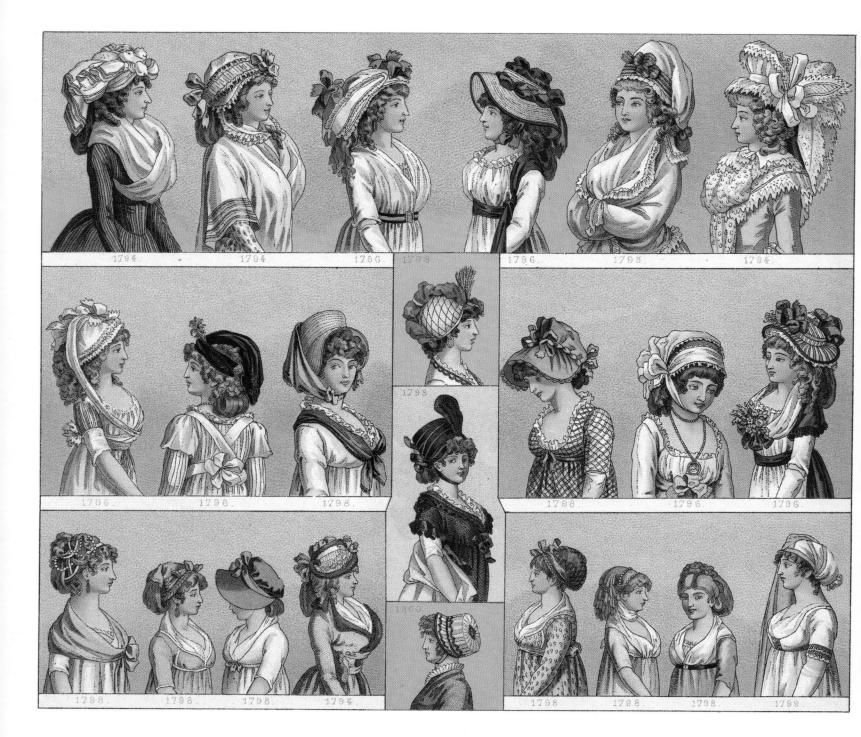

PLATE 82 · Women's Fashions, France, 1794–1800.

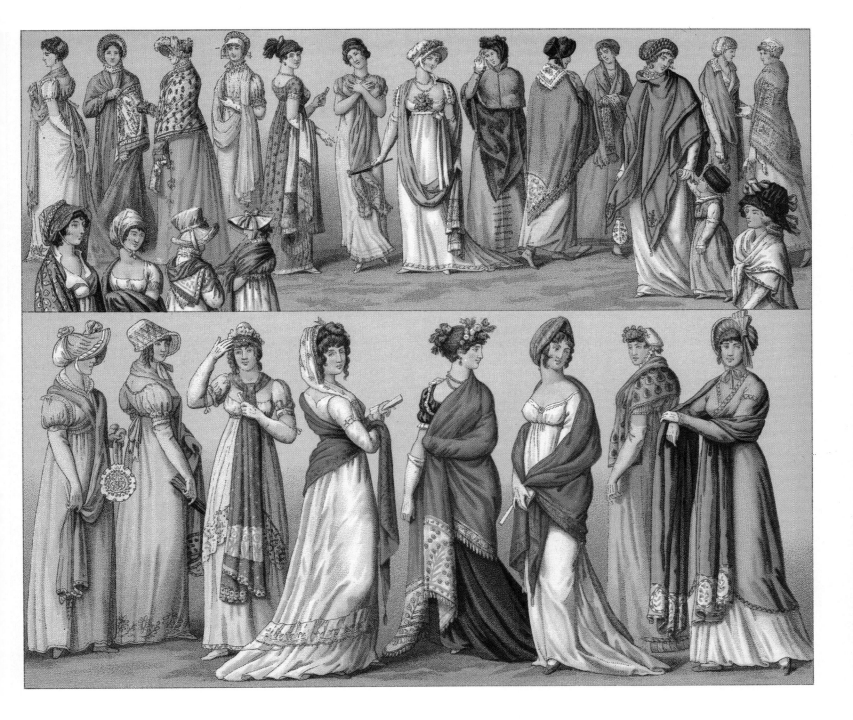

PLATE 83 · Cashmere and Other Shawls, France, 1794–1811.

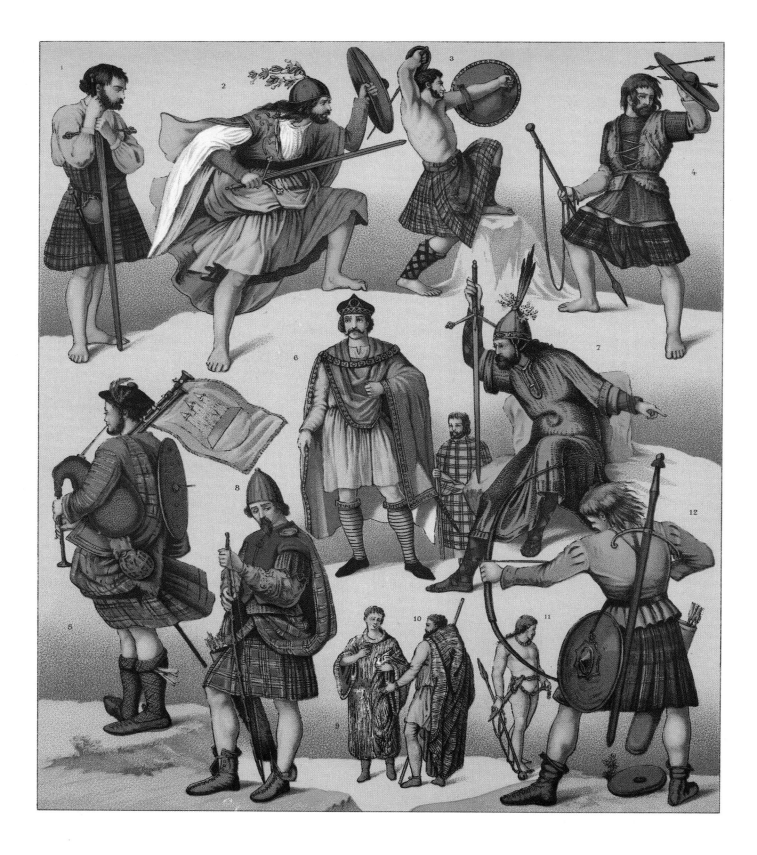

PLATE 84 · Scotland.

1: Clan MacDougal of Lorn. 2: Clan Ferguson. 3: Clan MacMillan. 4: Clan MacInnes. 5: Clan MacCrimmon. 6: Clan MacColl. 7: Clan MacDonald of the Isles. 8: Clan MacLaurin, early medieval period. 9: Welsh bard. 10: Irish bard. 11: Pict. 12: Clan of the MacQaaries.

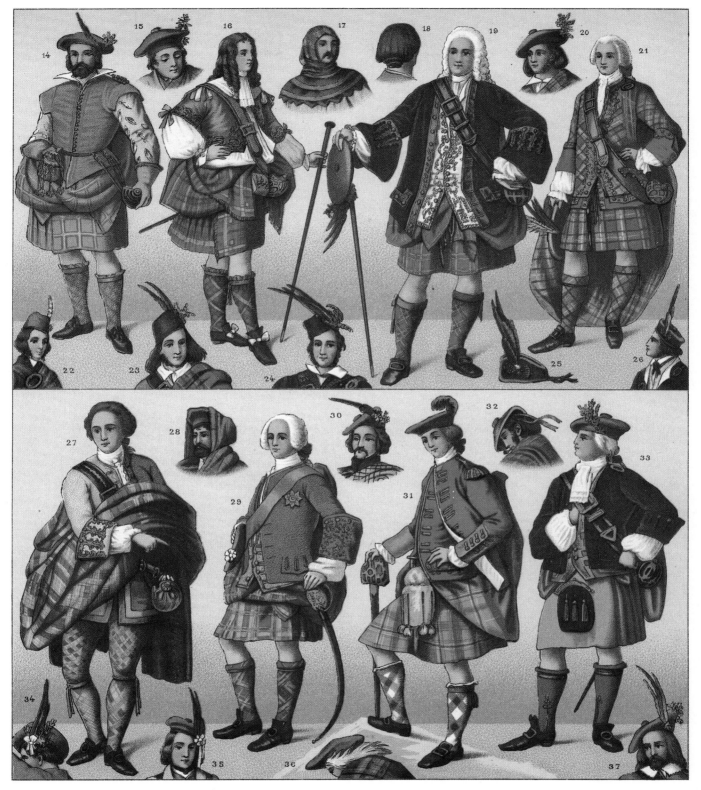

PLATE 85 · Scotland.

14: A laird of the clan of the Skenes, era of James VI (I of England). 15: Clan of the Graennes. 16: Member of Clan Robertson at the court of Louis XIV. 17: Clan MacIvor. 18: Clan of the Grants of Glenmoriston. 19: Clan MacIntosh, court dress, early 18th century. 20: Clan MacLeod. 21: Forbes, court dress, 1740. 22: Clan MacDonell of Glengarry. 23: Clan of the Frasers. 24: The Chisholms. 25: A glengarry of the Campbells of Breadalbane. 26: Menzies. 27: Clan of the Ogilvies, 1745. 28: The Davidsons. 29: Prince Charles Edward Stuart, ca. 1745. 30: Clan Buchanan. 31: The Kennedys (William, Count of Sutherland, ca. 1759). 32: Clan of the MacMachtans. 33: The MacIntyres, 18th century. 34: The Murrays. 35: The MacDonalds of Clan Ranald. 36: The MacAulays (old man in a snowstorm). 37: Clan MacLean, era of Charles I.

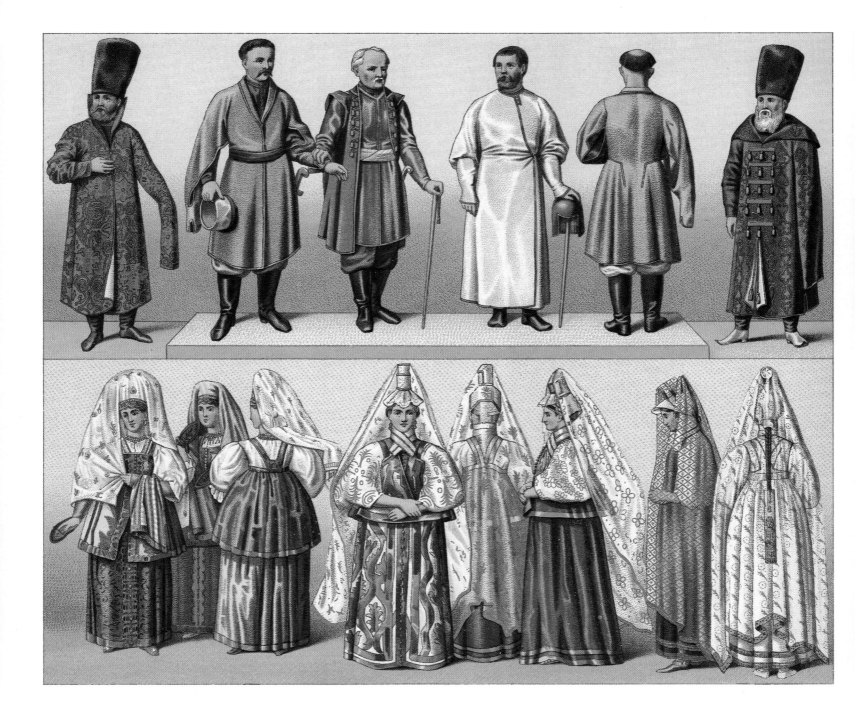

PLATE 86 · Russia, 17th Through 19th Centuries.

TOP, LEFT TO RIGHT: Boyar, 17th century; the cossack Brechka, wearing a caftan received from Peter the Great; the Cossack ataman, era of Peter the Great; boyar, morning wear, 17th century; Brechka, back view; boyar, 17th century. BOTTOM, LEFT TO RIGHT: Three women from the city of Tver; five women from the Tver *guberniya* in summer attire.

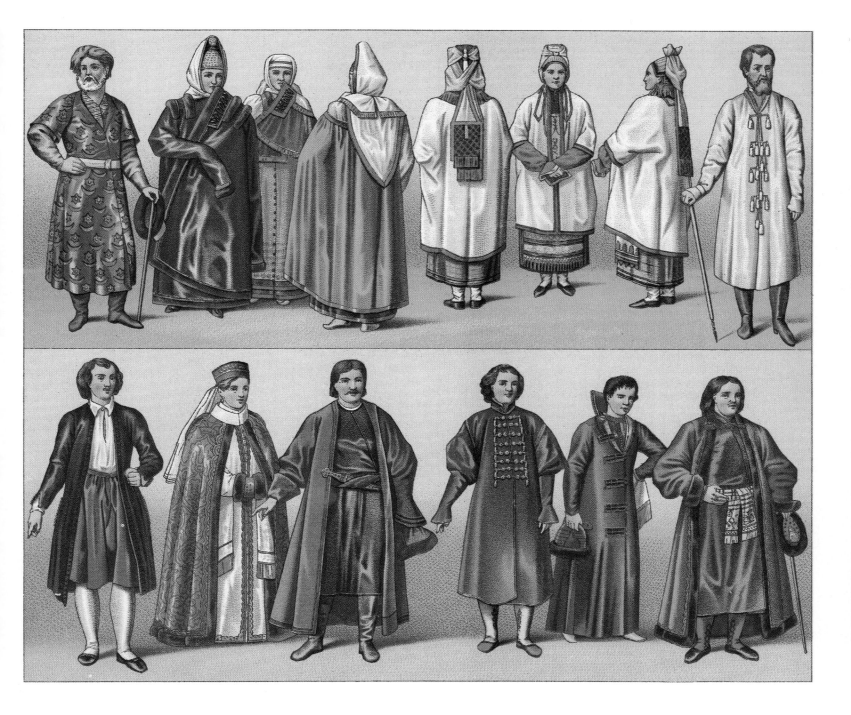

PLATE 87 · Russia, 16th Through 19th Centuries.

TOP, LEFT TO RIGHT: The boyar Boris Godunov (before he became tsar) in military dress; three women from the Tver *guberniya* in winter attire; three women from Ryazan; Ivan the Terrible.
BOTTOM, LEFT TO RIGHT: Peter the Great in naval uniform; a boyar's daughter, era of Peter the Great; a Prince Repnin, early 18th century; Peter the Great in a Polish-style caftan; Prince Peter Repnin, ca. 1645; the boyar Lyov Narishkin, 17th century.

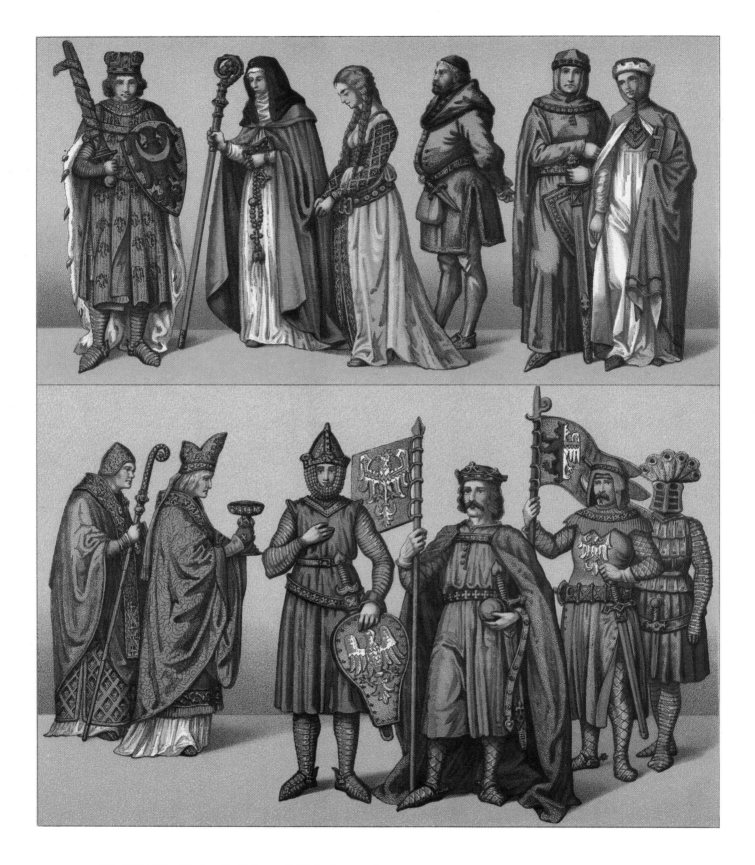

PLATE 88 · Poland, 13th and 14th Centuries.

TOP, LEFT TO RIGHT: Henry IV, the Just, duke of Silesia, died 1290; an abbess of the convent of Cistercians at Trebnitz, 14th century; girl of the nobility; townsman; Conrad, duke of Mazovia (died 1237) and his wife Oafia. BOTTOM, LEFT TO RIGHT: An abbot of the abbey of Oliva near Danzig, 1307; a bishop; Boleslav V, died 1279; Vladislav IV, died 1333; Leszek II, died 1289; Przemyslav, duke of Oppeln, died 1295.

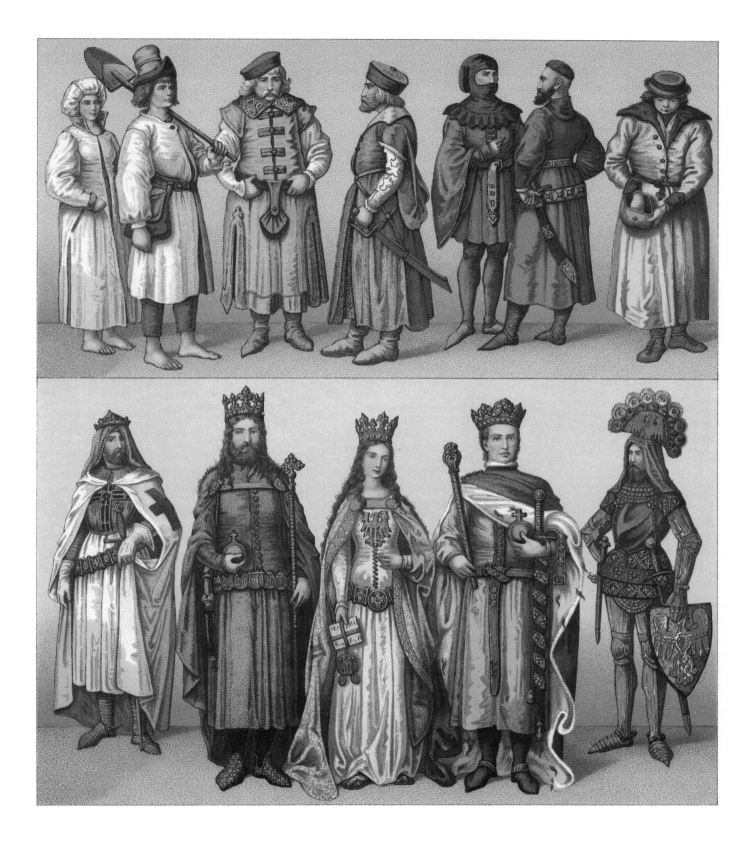

PLATE 89 · Poland, 14th and 15th Centuries.

TOP, LEFT TO RIGHT: Peasant woman and man from the outskirts of Krakow, in work clothes, 14th century; two gentlemen, second half of 15th century; townsman and gentleman in clothing worn between 1333 and 1434; peasant from the palatinate of Mazovia. BOTTOM, LEFT TO RIGHT: Grand Master of the Teutonic Order; Casimir III, died 1370; Jadwiga of Anjou, queen of Poland, 1384; Vladislav V, died 1434; Vladislav, duke of Appeln, 1378.

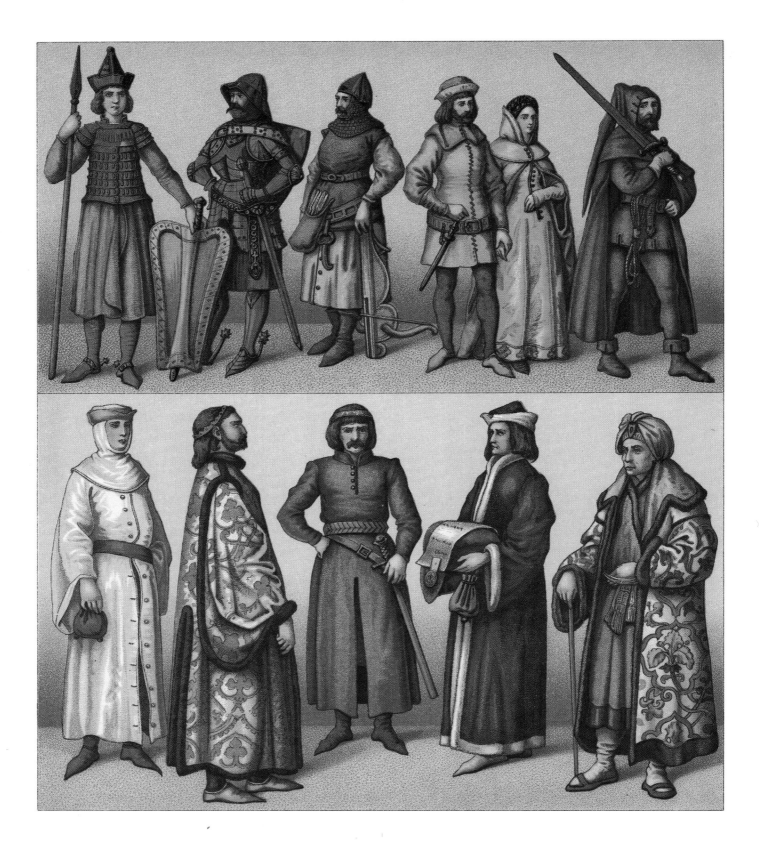

PLATE 90 · Poland, 14th and 15th Centuries.

TOP, LEFT TO RIGHT (all 14th-century): Ziemowit, prince of Wiszna; Kieystut, prince of Troki; crossbowman; townsman; lady of the lesser nobility; executioner. BOTTOM, LEFT TO RIGHT (all 14th-century except the last): Townsman; a magnate; gentleman; judge; rich townsman, second half of 15th century.

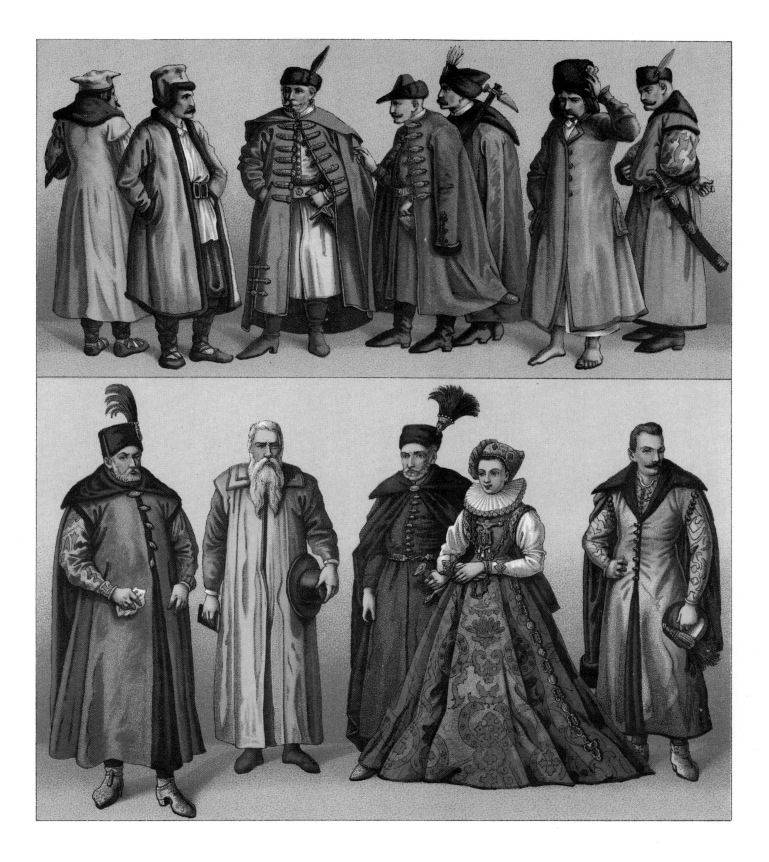

PLATE 91 · Poland, 16th Century.

TOP, LEFT TO RIGHT: Two Lithuanian peasants; three noblemen, last quarter of century; peasant from the outskirts of Kalisz; townsman, end of century. BOTTOM, LEFT TO RIGHT: Stephen Bathory, king of Poland 1575–1586; a municipal magistrate of Kazimierz; Stanislas Zolkiewski, chief hetman of Poland; daughter of a magnate; Roman Sanguszko, marshal of Lithuania, end of century.

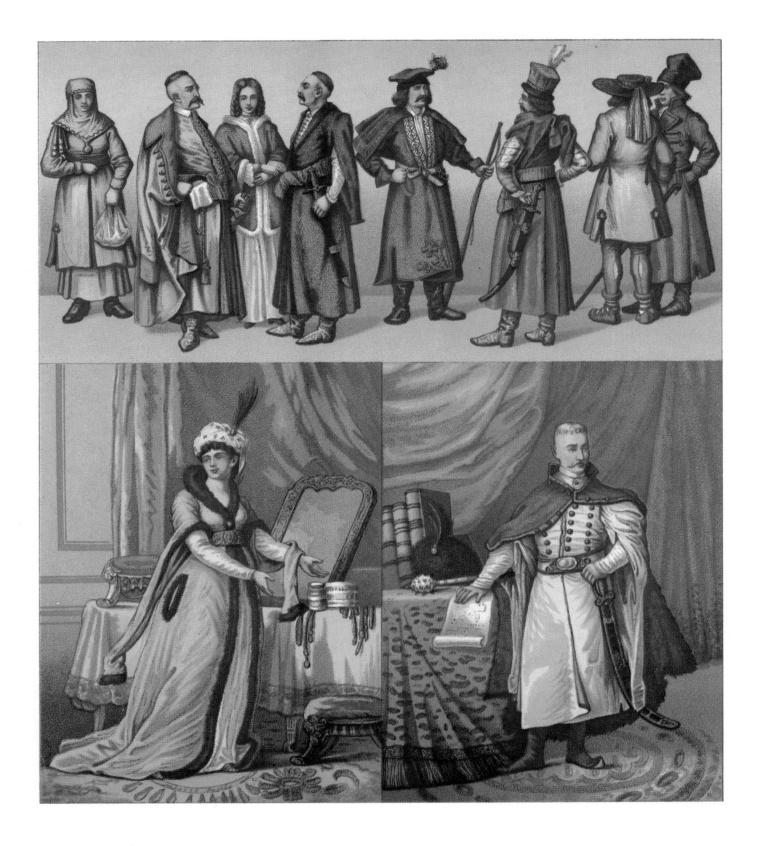

PLATE 92 · Poland, 18th and 19th Centuries.

TOP, LEFT TO RIGHT: Lithuanian peasant woman; three noblemen; peasant from the environs of Krakow; nobleman; mountaineer from the Carpathians; peasant from the palatinate of Lublin. BOTTOM, LEFT TO RIGHT: Great lady; the Constable of Poland.